IMAGES
of America

SOUTH BRONX

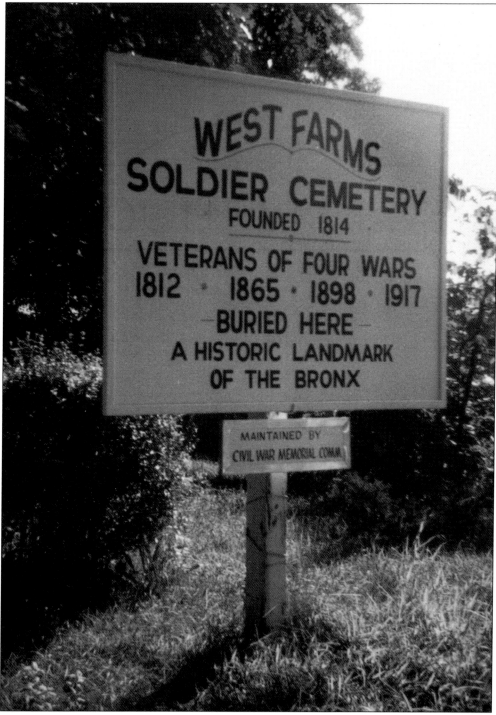

The West Farms Soldier Cemetery was established by John Butler in 1814 and holds about 114 interments, including veterans of the War of 1812, the Civil War, the Spanish-American War, and World War I. Located at Bryant Avenue and East 180th Street, it was designated a landmark in 1967. This sign was erected in 1972. (Courtesy John McNamara.)

IMAGES
of America

SOUTH BRONX

Bill Twomey

ARCADIA
PUBLISHING

Published by Arcadia Publishing
Charleston, South Carolina

Printed in the United States of America

Library of Congress Catalog Card Number: 2002101271

For all general information contact Arcadia Publishing at:
Telephone 843-853-2070
Fax 843-853-0044
E-mail sales@arcadiapublishing.com
For customer service and orders:
Toll-Free 1-888-313-2665

Visit us on the Internet at www.arcadiapublishing.com

To my friend and mentor, John McNamara.

CONTENTS

ACKNOWLEDGMENTS

This book would not have been possible without help from some good friends. John McNamara, Thomas Casey, and Bill Armstrong provided many of the photographs presented herein. Bill Armstrong, a transportation expert, is also to be thanked for graciously taking the time to teach me the nuances of early transportation around the Bronx. Gratitude is also extended to Ron Schliessman, the Bronx Times Reporter, the Chippewa Democratic Club, the Bronx County Historical Society, the Wilson family, the Turco family, Arthur Seifert, John Collazzi, Jack Sauter, John Robben, Ernie Braca, Carol Twomey, Jack McCarrick, Mike Bosak, Ronald Rock, Esq., Tony DiPalma, and Ken Roberts. It is my hope that these photographs from various sources will now be preserved for future generations to enjoy.

INTRODUCTION

The Bronx is the only portion of New York City attached to the mainland. The Harlem River separates this northern borough from Manhattan, and the area was annexed to New York City from Westchester County in two parts. That section west of the Bronx River was annexed in 1874, and the eastern portion in 1895.

The cognomen South Bronx did not exist until the 1950s and came to symbolize destruction and ruin. Prior thereto, inhabitants referred to their neighborhoods by such names as Mott Haven, Melrose, and Morrisania. Later, further distinctions were often given in parochial terms, such as being from St. Jerome's, St. Luke's, and so on, referring to the Catholic parishes. Others would have proudly indicated that they lived on the Concourse, meaning the Grand Concourse, which became immensely popular for the beautiful Art Deco buildings with elevators and, often, doormen. This was before the great exodus that began in the early 1960s.

The South Bronx came to be defined as that area in the southwest Bronx between the Harlem River and the Bronx River. The northern boundary was never discussed with any unanimity. The terms "below Tremont Avenue" or "the Cross Bronx Expressway" were often used to describe the area. Today, however, Fordham Road holds the greatest consensus among local historians as the northern boundary. Even then, there are some who have a difficult time saying that Little Italy is in the South Bronx. This ethnic enclave has always provided an oasis of sanity in a sometimes turbulent borough.

The ruination of the South Bronx began with a quiet erosion during the 1950s. Some of the population began seeing signs of trouble and began moving north in the 1960s. By the 1970s, it became a torrent. By 1980, about half of the population of this area of the borough was gone. Empty buildings were abandoned by owners and were often taken over by squatters. Many were then set ablaze. Engine 82, Ladder 21 (on Intervale Avenue), became the busiest firehouse in the nation. The 41st Precinct of the New York City Police Department was constantly besieged. When an arrow came through one of its windows, it became known as Fort Apache. The South Bronx was now a regular on evening television and became known throughout the world as a symbol of blight.

Politicians came and went during election years, grandstanding on the ruins of burned-out buildings and lots strewn with rubble. There were a few heroes, however, and like a phoenix, the South Bronx would rise from the ashes and decay. Men like Fr. Louis Gigante, with his Southeast Bronx Community Organization, began rallying for change and would not be deterred. Other community leaders such as Genevieve Brooks and Yolanda Rivera saw the

rise of Banana Kelly and other community-based improvement associations. These inspired leaders—along with effective public servants, such as the borough president—continued the struggle for rebirth.

Charlotte Street, where presidents once stood among ruin, is now one of the cleanest streets in New York City and is a desirable place to live. These well-tended homes, which once sold for about $50,000, now command over $200,000 if they go on the market—a rare occurrence. People in this community are not anxious to leave. There is something to be said for effective leadership and pride of ownership. Some sections of the South Bronx have truly risen, proving that SoBro, as the natives often call it, can be a friendly place once again.

I have made every effort in this modest work to concentrate on what is positive about the South Bronx. The number of images that can be presented is limited, and I have concentrated on the earlier part of the 20th century, which will be recalled by some older readers. I have also sought to bridge the gap between the old and the new through the available photographs. Hopefully, the result will bring to mind pleasant memories for some and will project a story of transition and hope for others. The South Bronx has come a long way in recent years, and the outlook for tomorrow is bright.

—Bill Twomey

One

TRANSPORTATION

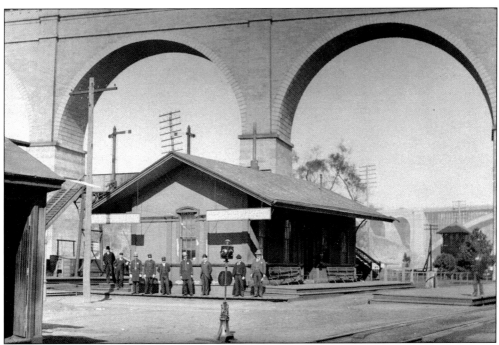

The Highbridge Station, located at the foot of Depot Place, opened *c.* 1871 to serve trains from both the Hudson and Putnam lines. It was a popular stop for excursions to nearby hotel resorts such as Woodbine Cottage, as well as for the ever popular Kyle's Amusement Park. The Metropolitan Transportation Authority was installing high-level platforms in 1973, and this station was abandoned at that time due to low patronage. Penn Central was operating the Hudson, Harlem, and New Haven suburban rail service under its contract with the Metropolitan Transportation Authority at that time. (Courtesy Ronald Rock, Esq.)

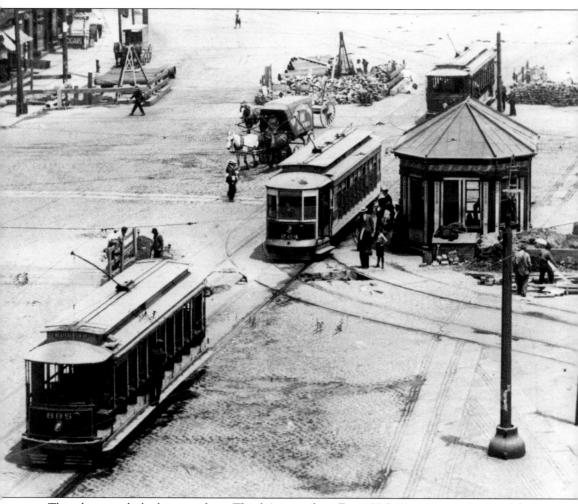

This photograph, looking north on Third Avenue from East 137th Street, was taken on July 1, 1913. The streetcars in the photograph are of interest, for they typify summertime operations on a street railway of that era. The middle car, No. 224, is a convertible that featured removable side panels of screens for the summer and wood and glass for the winter. This car was built in 1911 and was one of 515 similar convertibles that were built for the Third Avenue Railway System between 1908 and 1911. The other two cars are open cars that were operated only during the summer months. No. 885, in the foreground, is a 12-bench car built in 1900. The open car in the rear, No. 533, is a slightly larger 14-bench car that was built in 1904. All open cars were removed from service in 1932, but the convertibles continued in use until the end of the streetcar operation in the Bronx in 1948. The waiting station in the picture was replaced sometime in the early 1930s by a substantial combination comfort station and heated waiting room with benches. The tracks veering off to the right in the foreground are heading into Lincoln Avenue. (Courtesy Bill Armstrong.)

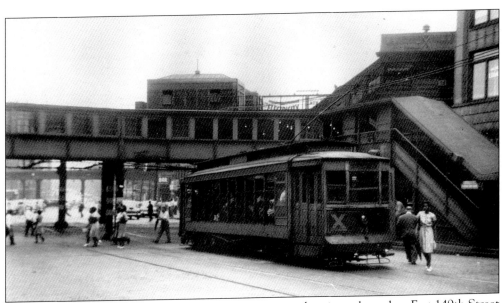

This No. 71 convertible on the X 149th Street crosstown line is eastbound on East 149th Street at Third Avenue in the Hub. The photograph was taken in the summer of 1947, and open screens are in place in the streetcar. The scene is dominated by the Third Avenue elevated and its overhead walkway across to the north side of the street and Melrose Avenue. The other elevated structure, seen dimly in the background, is the Bergen Avenue connector, which was used by rush-hour elevated trains for service to Freeman Street on the Bronx Park–White Plains Road line. That service, which was originally operated by Second Avenue elevated trains, was dropped in 1946. (Courtesy Bill Armstrong.)

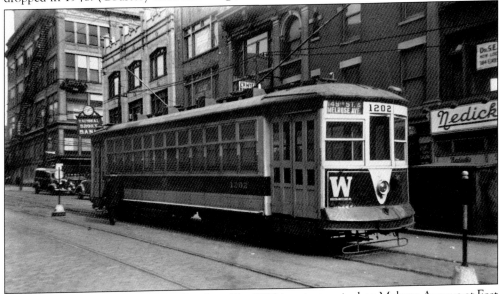

This W Webster and White Plains Road car No. 1202 is at its terminal on Melrose Avenue at East 149th Street. The motorman is changing ends and has just raised the trolley pole at what will be the rear end of the car's northbound run. He is walking forward to pull down the pole at what will be the front end. This car originally operated in Staten Island and was acquired for service in the Bronx when the streetcars in that borough were replaced in 1934. (Courtesy Bill Armstrong.)

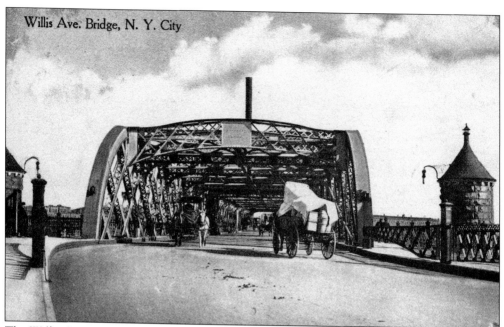

Willis Ave. Bridge, N. Y. City

The Willis Avenue Bridge was opened to traffic on August 22, 1901. Reaching into Manhattan at East 125th Street, it spans the Harlem River at the junction of Willis Avenue and Bruckner Boulevard. (Courtesy Thomas Casey.)

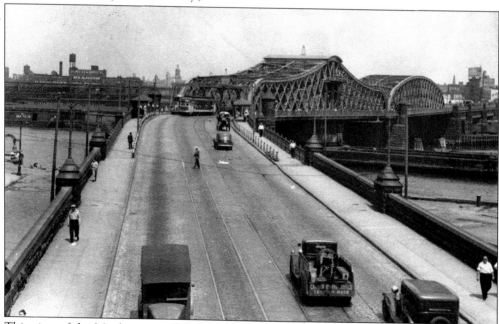

This view of the Manhattan end of the Willis Avenue Bridge was taken on August 5, 1941—the last day of service for the Willis Avenue streetcar line, which ran between Fordham Road and the Fort Lee Ferry. The line was replaced by buses on that day because the City of New York had just instituted one-way traffic operations on the Willis Avenue and Third Avenue Bridges, with southbound traffic on the Third Avenue Bridge and northbound traffic on the Willis Avenue Bridge. (Courtesy Bill Armstrong.)

This interesting picture was taken in February 1938 at the point where the Major Deegan Expressway was under construction at Willis Avenue between East 134th and East 135th Streets. The southbound W Willis Avenue streetcar is on the temporary shoo-fly (bypass) trackage that took it around the site of the construction of the new overpass being built to carry Willis Avenue over the new expressway. Although the Triborough Bridge opened on July 11, 1936, some of the connecting highway links were not completed until much later. (Courtesy Bill Armstrong.)

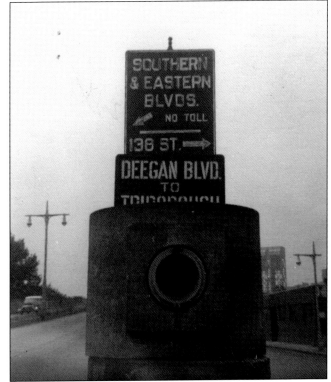

This photograph shows the signage for the Major William F. Deegan Boulevard, which was later changed to the Major Deegan Expressway. It shows the approach to the Triborough Bridge, with an arrow pointing to Southern and Eastern Boulevards and another to East 138th Street. The name Eastern Boulevard was changed to Bruckner Boulevard in 1942. (Courtesy John McNamara.)

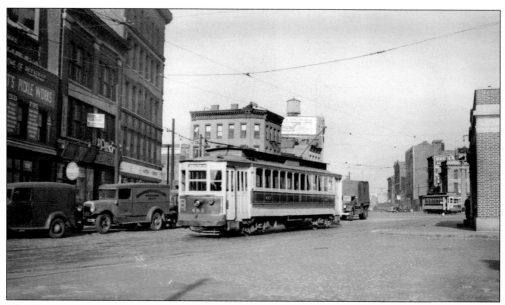

This B Boston Road car is at its terminus on Third Avenue just south of East 138th Street. It is evident that this photograph was taken before 1941—there is an M Morris Avenue car in the background, and buses replaced that line on the last day of 1940. The brick structure on the right is a comfort station that also housed a heated waiting room with benches. Note the pickle works at the left, a common industry in the Bronx prior to World War II. Both the comfort station and the pickle works have long vanished from this scene, along with the streetcars. (Courtesy Bill Armstrong.)

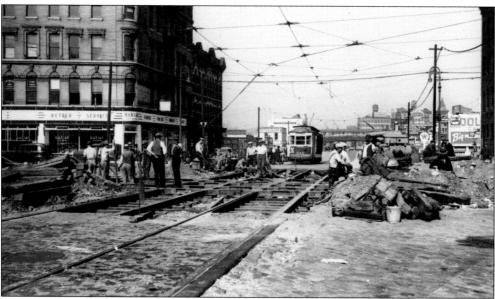

This September 1938 view looks toward the west at East 138th Street and Third Avenue, where the Third Avenue Railway System was replacing crossings and turnouts at the intersection of its B Boston Road and X 138th Street crosstown lines. Note that not one of the numerous workmen is without a hat. (Courtesy Bill Armstrong.)

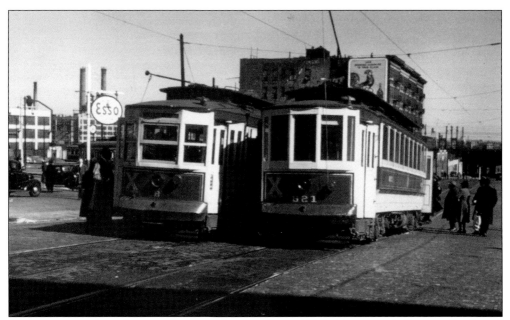

Looking east, this photograph was taken at East 138th Street and Eastern Boulevard c. 1941. Today, the elevated Bruckner Expressway dominates this scene. The trolley at the left, No. 8, is westbound and is a convertible. Judging by the heavy clothing on those boarding it, the wood-and-glass side panels would be in place. The one on the right, No. 821, is heading toward Port Morris. It is not a convertible and has longitudinal seats in its interior. Note the old Esso sign at the left. (Courtesy Bill Armstrong.)

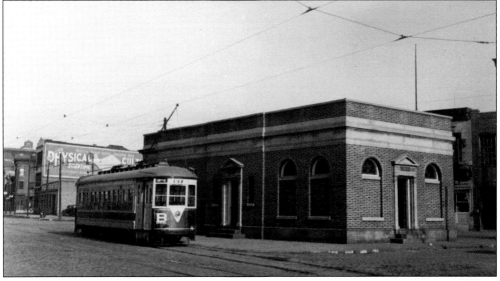

This is a great view of the combined comfort station–waiting room at Third Avenue and East 138th Street, with car No. 137 waiting to begin its run up to the Morris Park section of the Bronx on the B Boston Road. This car was one of 335 cars that were built by the Third Avenue Railway System in its own main shops at 65th Street and Third Avenue in Manhattan between 1934 and 1939. The picture was taken in the summer of 1948, shortly before buses replaced the line on August 22. (Courtesy Bill Armstrong.)

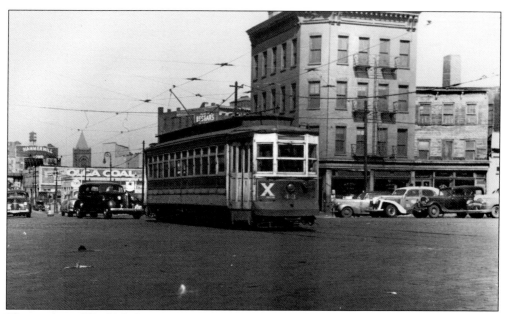

This eastbound X 138th Street crosstown car is crossing Third Avenue in 1947. Note the clock tower of the New York Central's 138th Street Station in the left background. It has the pointed roof and was a popular landmark for years. It was built in 1886 and demolished in 1964. The wood-framed structure at the extreme right was typical of the buildings in the Mott Haven area, which was first heavily developed in the 1860s and 1870s. (Courtesy Bill Armstrong.)

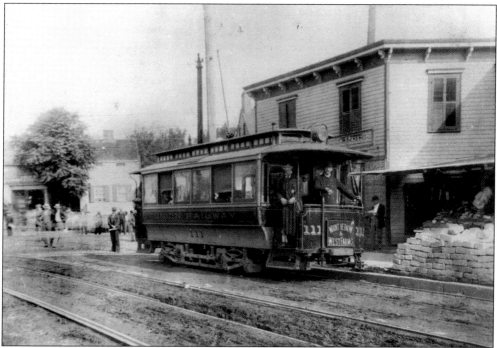

Union Railway car No. 111, preparing for the return trip to Mount Vernon, is at West Farms Road in front of Daniel Mapes General Store. The store was established in 1869 and handled hardware, paints, oils, flour, feed, and seeds among other things. (Courtesy Ronald Schliessman.)

This view of West Farms Square was taken from the elevated structure of the Bronx Park–White Plains Road subway line on September 4, 1939. West Farms was a very busy junction on the Third Avenue Railway System's network of Bronx street railway lines. It was served by the B Boston Road, C Bronx and Van Cortlandt Parks, T Tremont Avenue, V Williamsbridge, and Z 180th Street crosstown lines. The bus in view, which was operated by the North Shore Bus Company, has just arrived from Queens via the new Bronx-Whitestone Bridge, which opened on April 30, 1939. The New York City Board of Transportation took over the North Shore routes in 1947. This line is now the New York City Transit Authority's route Q44. (Courtesy Bill Armstrong.)

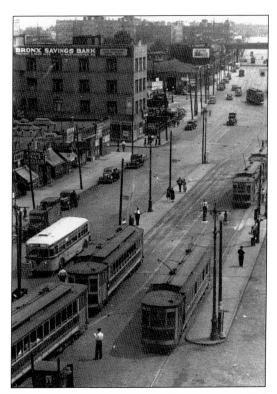

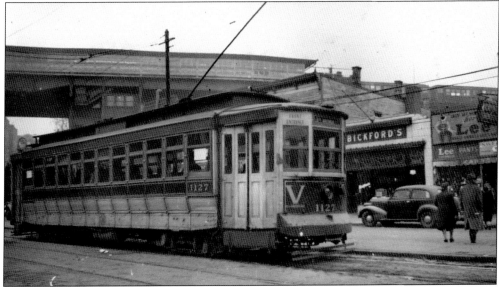

A westbound V Williamsbridge convertible, No. 1127, is waiting to depart from West Farms Square in December 1942. Convertibles were streetcars that were equipped with removable side panels, which could be replaced with screens during the summer. The passengers could pull down interior waterproof curtains in the event of rain. All of the Third Avenue Railway System's convertibles were built in 1908 and 1909, and the last of them were retired in 1948. The glass panels in this car indicate that the cold weather has arrived. Note the Bickford's to the right. (Courtesy Bill Armstrong.)

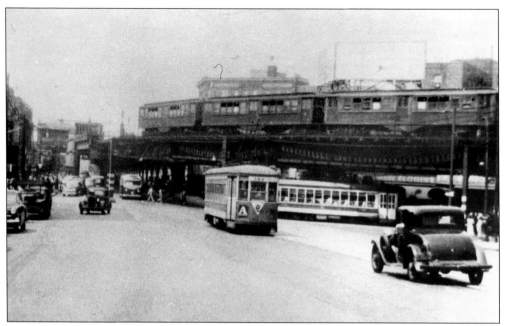

This 1948 summer scene is unique because it features so many modes of transportation. There is a southbound A Westchester Avenue car, a northbound S Southern Boulevard car under the elevated structure, a northbound Bronx Park–White Plains Road train leaving the Simpson Street station, and a new GMC bus. The new bus was probably used for transition training of motormen to bus operators during these last days of streetcar operation in the Bronx. (Courtesy Bill Armstrong.)

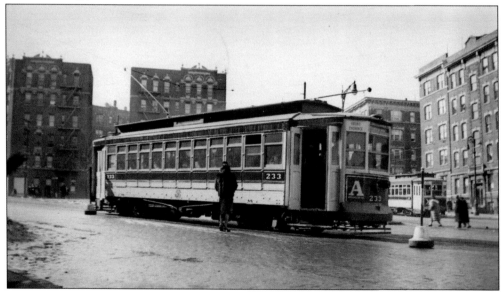

This cold winter scene was taken on February 21, 1943, at the intersection of Westchester Avenue and East 167th Street. Car No. 233 on the A Westchester Avenue car line is headed toward Westchester Square. Another streetcar can be seen in the background on the X 167th Street crosstown at its terminal point. After changing ends, it will head for its western terminal at West 181st Street and Broadway in Manhattan. (Courtesy Bill Armstrong.)

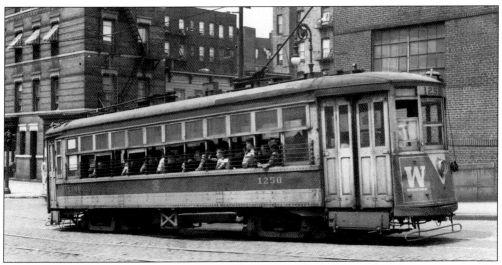

Car No. 1250, which was one of the Third Avenue Railway's secondhand cars, came to the Bronx from Kankakee, Illinois, in 1930. It is seen here on the W Webster Avenue and White Plains Road line at Melrose Avenue and East 163rd Street, having just crossed the bridge over the New York Central's Port Morris branch. The car is not a convertible, but note the children hugging the safety bars to catch a breeze on what appears to be a hot summer day in July 1948. This line was one of the system's longest, extending from East 149th Street and Melrose Avenue to the city line at East 243rd Street and White Plains Road. (Courtesy Bill Armstrong.)

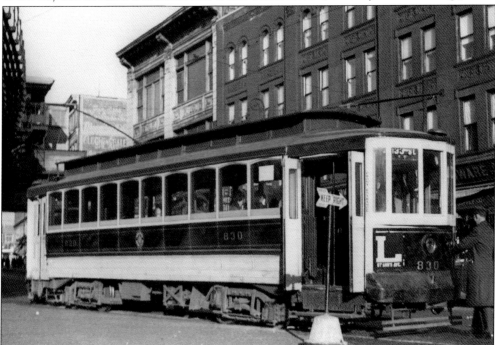

An L St. Ann's Avenue streetcar is at its northern terminal at East 161st Street and Third Avenue. The motorman is completing his task of changing ends by tying down the front trolley pole and is about to begin his run down St. Ann's Avenue to East 133rd Street. The Third Avenue elevated line is at the extreme left. (Courtesy Bill Armstrong.)

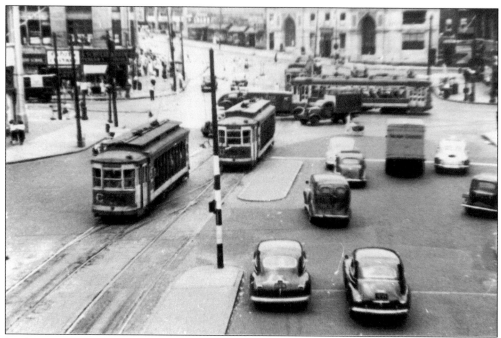

Looking west on Fordham Road over Webster Avenue, this 1940s photograph was taken from the Third Avenue elevated line. It is a good example of the intense trolley traffic at Fordham Plaza. (Courtesy Ronald Schliessman.)

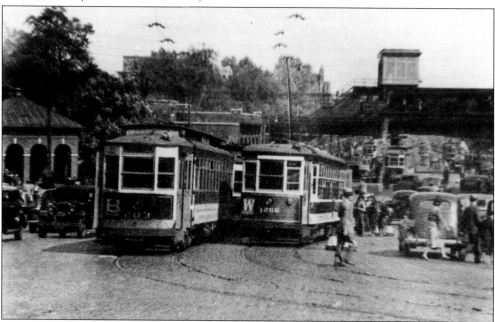

Several modes of transportation are shown in this photograph. The B No. 203 trolley, the W No. 1256, and many vehicles are in the foreground on Fordham Road. The No. 1256 was purchased used from the Lake Superior District Power Company in Michigan. The Third Avenue elevated line is in the background. The view looks east from Webster Avenue. (Courtesy Ronald Schliessman.)

Vernon Seifert piloted a Piper Cub out of Flushing Airport to take this photograph of East Tremont Avenue and the Third Avenue elevated line. The view is to the northeast. The pilot's brother Arthur was the photographer. (Courtesy Arthur Seifert.)

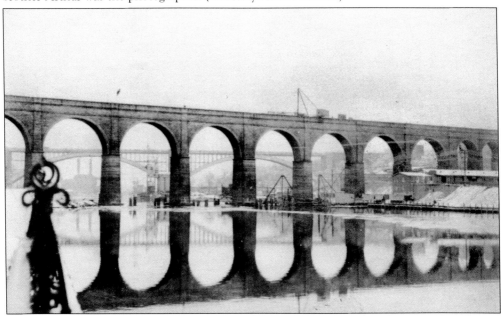

High Bridge spans the Harlem River from 174th Street and Amsterdam Avenue in Manhattan to University Avenue at West 170th Street in the Bronx. It was erected between 1839 and 1848 but was sufficiently complete on July 4, 1842, to begin carrying water into the city, the function for which it was built. This photograph was taken on December 27, 1926. Note the mirror image in the river. (Courtesy John McNamara.)

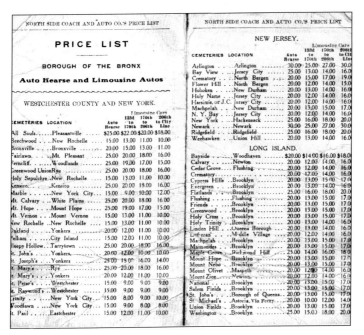

This fascinating price list from the North Side Coach & Auto Company offers the services of both hearses and limousines. Local depot calls are only $10 for a hearse and $6 for a limousine. The reverse gives a complete breakdown for Westchester, New York, New Jersey, and Long Island cemeteries. The company maintained three offices, which included a Melrose branch at 677 Elton Avenue, a Tremont branch at 1908 Bathgate Avenue, and a Fordham branch at 189th Street and Webster Avenue.

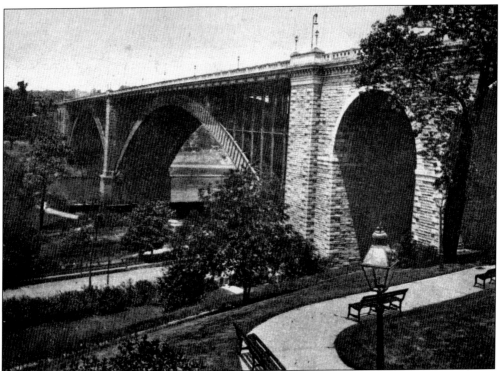

The Washington Bridge spans the Harlem River from West 180th Street in Manhattan to University Avenue near West 172nd Street in the Bronx. Construction began in July 1886 and was sufficiently complete in December 1888 to be opened to traffic. (Courtesy John McNamara.)

The Putnam Bridge, built in 1881, spans the Harlem River between West 155th Street and Eighth Avenue in Manhattan to the Jerome Avenue line in the Bronx. Built as a railroad bridge for the New York City and Northern Railroad Company, it also had a pedestrian walkway, which was frequently used by baseball fans from the Bronx to access the Polo Grounds. It was later converted to a spur to connect the Ninth Avenue elevated line to the Jerome Avenue line. The bridge was opened to traffic on May 1, 1881. (Photograph by John McNamara.)

Ronald Schliessman took this photograph of John McNamara next to his canoe in 1963. McNamara was on one of his famous canoe trips and was preparing to paddle against the very visible tidal current of the Bronx Kill. The view is to the southwest, with the Triborough Bridge and Randall's Island in the background. (Courtesy John McNamara.)

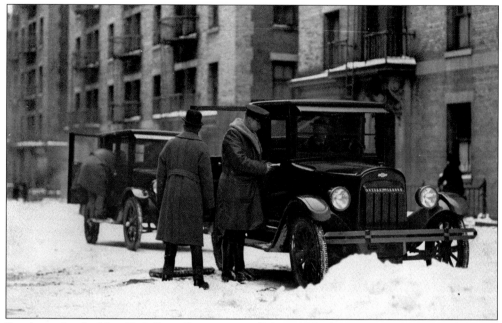

Road tests for the New York State Department of Motor Vehicles were once given on the quiet traffic-free streets of Hunts Point. In this late-1920s view, inspection officer William Higgs is giving a driving test to a would-be driver who also has some snow to contend with. The vehicle is a Chevrolet from-c. 1925. (Courtesy Arthur Seifert.)

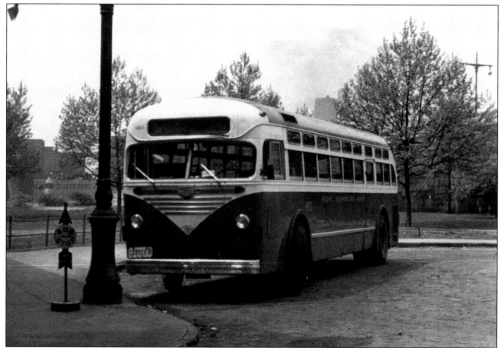

This Surface Transportation System bus is seen at East 138th Street and the Grand Concourse. It is a Mack C-45, No. 1913, which plied the popular Bronx route No. 1. The photograph was taken on May 4, 1952. (Courtesy Bill Armstrong.)

Two

PRAYERFUL PEOPLE AND PLACES

St. Ann's Protestant Episcopal Church, located at St. Ann's Avenue and East 140th Street, is one of the most historic sites in the South Bronx. This image portrays one of the church's choirs of an earlier era. (Courtesy Thomas Casey.)

Gouverneur Morris II established St. Ann's Protestant Episcopal Church in honor of his mother, Ann Morris, in 1841. This historic church contains the remains of Gouverneur Morris, a framer of the Constitution; Lewis Morris, a signer of the Declaration of Independence; and many other Morris family members. Richard Hoe, the inventor of the rotary printing press, was a vestryman at the church. He, too, is entombed there. The building was declared a landmark on June 9, 1967. (Courtesy Thomas Casey.)

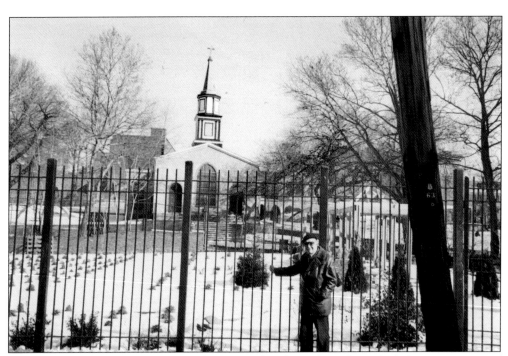

John McNamara is standing against the fence of Padre Park on East 139th Street just west of St. Ann's Avenue. The park was named for Fr. Roger Giglio, OFM, who had always been referred to simply as "Padre." He passed away in 1990. The beautiful structure in the background is St. Ann's. (Photograph by Bill Twomey.)

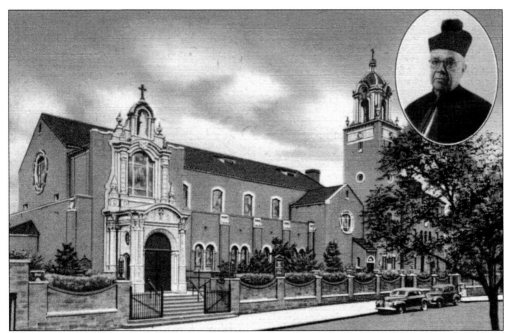

St. Roch's Roman Catholic Church was founded in 1899 to serve the growing Italian population of the area. Fr. John Milo was the first pastor of the little wooden church on Jackson Avenue at East 150th Street. Msgr. Ignatius Cirelli is credited with erecting the beautiful structure seen here. It was dedicated on Columbus Day 1932 and is located at 525 Wales Avenue south of East 149th Street. (Courtesy Thomas Casey.)

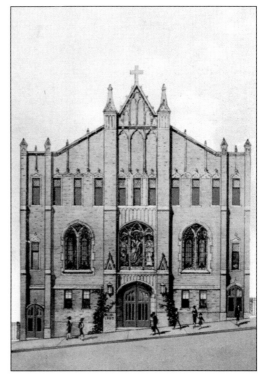

The Swedish Finnish Lutheran Church, located at 923 Woodycrest Avenue, had long been considered one of the most beautiful churches in Highbridge. (Courtesy Thomas Casey.)

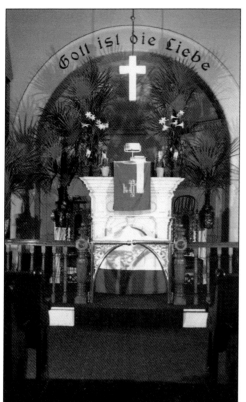

The Melrose Reformed Church, also known as St. Matthew's Church, was constructed on the south side of East 156th Street between Melrose and Courtlandt Avenues. It catered to the large German population of the area. The sign above the altar can be translated as "God is Love." The Evangelical Lutheran congregation was established in 1862, but the latest structure dates from 1895. (Courtesy John McNamara.)

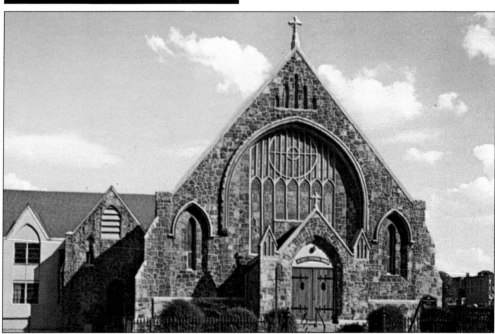

St. Paul's Protestant Episcopal Church was organized in 1849, but the edifice shown here dates from 1895. The distinctive English Gothic–style construction set it apart from other churches in Morrisania. The location is Washington Avenue at St. Paul's Place. (Courtesy Thomas Casey.)

The Church of the Immaculate Conception, located at East 150th Street and Melrose Avenue, was established in 1853 with Rev. Caspar Metzler as the first pastor. The cornerstone to the current edifice was laid on September 25, 1887, with Archbishop Michael Corrigan presiding. The solemn dedication took place on December 23, 1888. It, too, had long served a strictly German population, but most members of the congregation are now of Hispanic origin. (Courtesy Thomas Casey.)

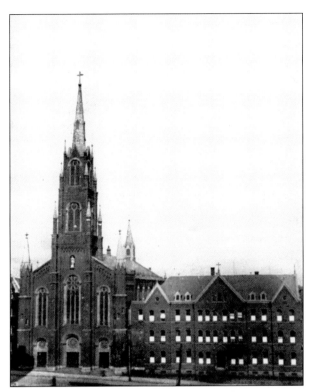

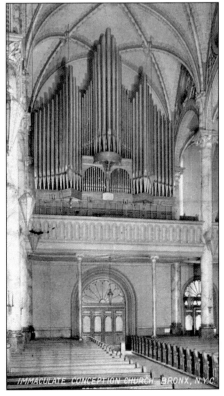

The W.W. Kimball Company installed this outstanding organ in the Church of the Immaculate Conception in 1903 as part of the preparation for the celebration of the parish's golden jubilee. It was completely renovated by the same company in 1913. (Courtesy Thomas Casey.)

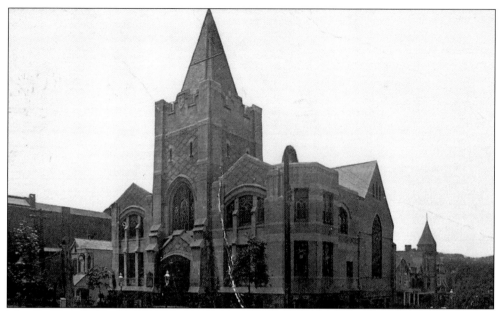

The Tremont Methodist Episcopal Church was built at the southwest corner of Washington Avenue and East 178th Street. (Courtesy Thomas Casey.)

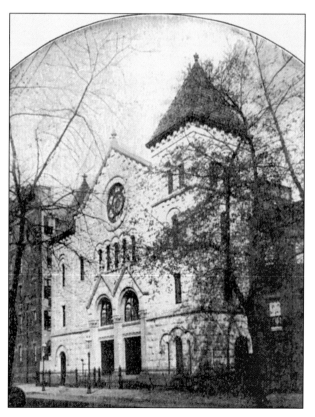

The beautiful Congregational Church of North New York was constructed on the north side of East 143rd Street just east of Willis Avenue. (Courtesy Thomas Casey.)

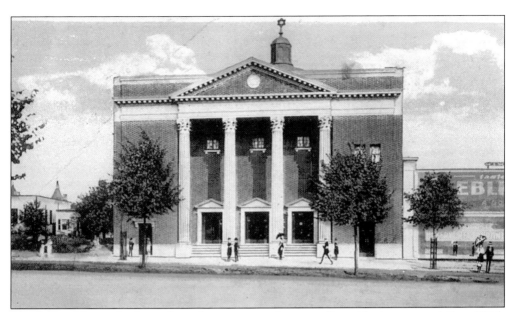

This beautiful temple, located on the concourse between Burnside Avenue and East 180th Street, was constructed to serve the many Jewish families who migrated to the Grand Concourse. The congregation continued to grow as Jews moved into the nearby Art Deco buildings, many of which had doormen and elevators. There were over a half million Jews in the Bronx by 1930, comprising almost half of the population of the borough. (Courtesy Thomas Casey.)

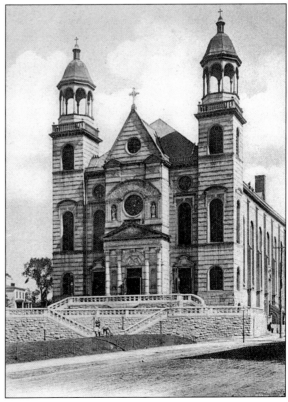

St. Augustine's Parish was established in 1849 at Jefferson Place off Boston Road. The original structure was later replaced by a larger one. When that wood-framed building was gutted by fire, the parish built the beautiful edifice seen here. It is located at 1183 Franklin Avenue off East 167th Street and was dedicated by Archbishop Michael Corrigan on November 24, 1895. The parish currently serves some 400 families, many of whom are drawn to the gospel music and camaraderie of Sunday morning worship. (Courtesy Thomas Casey.)

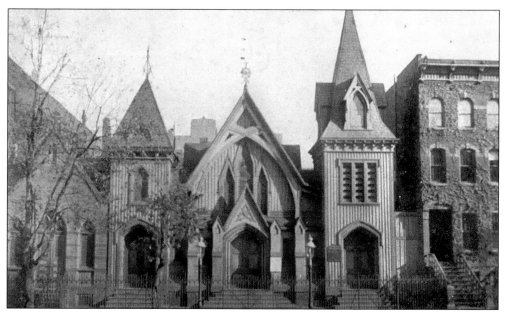

St. Mary's Church was established on the east side of Alexander Avenue between East 141st Street and East 142nd Street to serve the Protestant Episcopalian population of the area. (Courtesy Thomas Casey.)

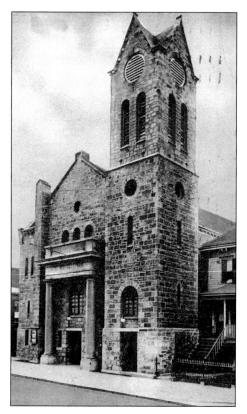

Rev. William Theodore Van Doren established the Mott Haven Reformed Church on land provided by Jordan L. Mott in 1850. The church, however, was not fully recognized until 1852, when Van Doren was officially installed as pastor of the 30-family congregation. The edifice shown here was constructed during the Civil War at the southwest corner of East 146th Street and Third Avenue. (Courtesy Thomas Casey.)

The Bright Temple African Methodist Episcopal Church is located at 810 Faile Street off the northeast corner of Lafayette Avenue. It was once the home of Peter A. Hoe, whose family is noted for their many advances in the printing industry. (Photograph by Bill Twomey.)

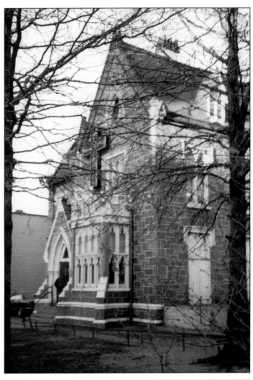

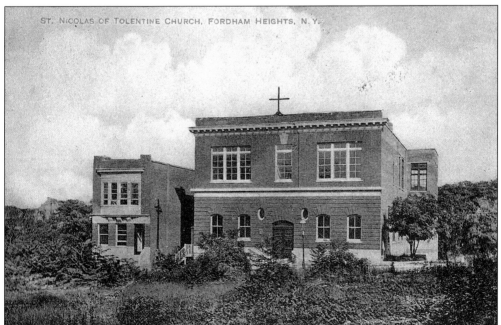

St. Nicholas of Tolentine Parish was created to serve the growing Irish population of Fordham, and Rev. Edward Drohan celebrated the first Mass there in 1906. The current Gothic church was dedicated on April 28, 1928, by Patrick Cardinal Hayes. It is interesting to note that Rev. Joseph O'Hare, the president of Fordham University, was raised in this parish and now resides only a few blocks from his childhood home. (Courtesy Thomas Casey.)

33

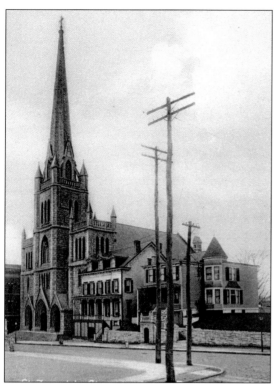

St. Joseph's Church, located at 1943 Bathgate Avenue, is another parish that had once served a large Irish population. It is located between East Tremont Avenue and East 178th Street. (Courtesy Thomas Casey.)

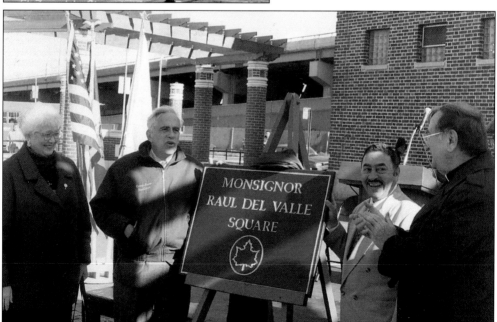

Monsignor Raul Del Valle Square was dedicated on October 28, 1997. It is located at Hunts Point Avenue and East 163rd Street. The monsignor was born in Cuba, where he served until forced to leave by the Bay of Pigs invasion. He was pastor of St. Anselm's Church from 1974 to 1980 and then served the parishioners of St. Athanasius. He passed away in 1988. Henry Stern, parks commissioner, is second from the left. Federico Perez, councilman, is third from the left.

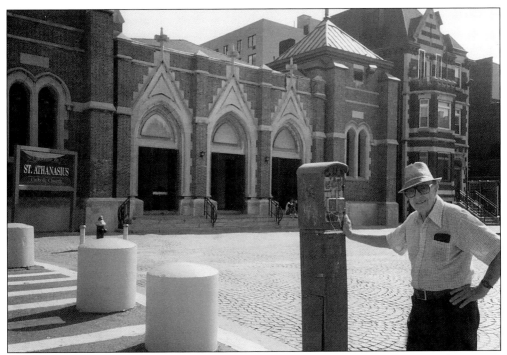

Bronx historian John McNamara poses on the plaza in front of St. Athanasius Church opposite Father Gigante Plaza. The site is located at Tiffany and Fox Streets and the photograph was taken on August 27, 1995. (Photograph by Bill Twomey.)

Noted Bronx historian and author John McNamara poses at Father Gigante Plaza on August 27, 1995. The plaza is located at Tiffany and Fox Streets across from St. Athanasius Church. (Photograph by Bill Twomey.)

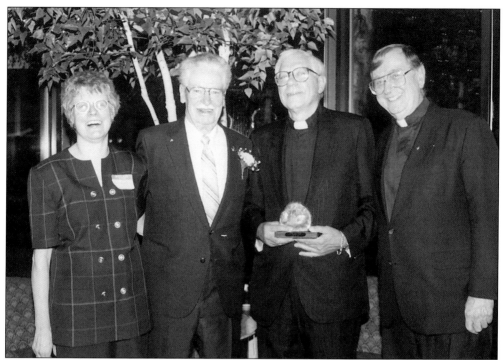

As part of the 85th anniversary celebration of St. Athanasius School, the Cardinal Cooke Award was presented to Fr. Louis Gigante. From left to right are Marianne Kraft, the principal; John Fischer, another honoree; Father Gigante; and Msgr. William Smith, the pastor. The ceremony took place in May 1999.

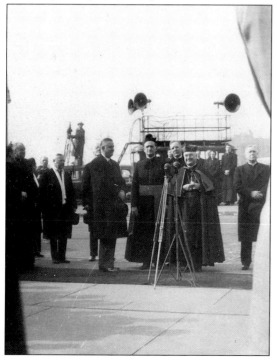

Francis Cardinal Spellman had just returned from Rome after being incardinated by Pope Pius XII on February 18, 1946. Upon his return to New York, the new cardinal went straight from Idlewild Airport to Cardinal Hayes High School, where a celebration would take place. The school, located at 650 Grand Concourse, was very special to the cardinal, who laid the cornerstone to the building on November 20, 1940, and maintained a strong association with the school. About 200 of the students greeted the new cardinal with a Latin hymn that had been composed for such an occasion. Seen with the cardinal in this photograph are borough president James J. Lyons and Msgr. Ed Waterson. (Courtesy Jack Sauter.)

Fr. Victor Pavis is shown in 1947. He is wearing his Hayes jacket to cheer on his team, as he was a popular teacher at Cardinal Hayes High School at the time. He later went on to pastoral duties and was elevated to monsignor. (Courtesy Jack Sauter.)

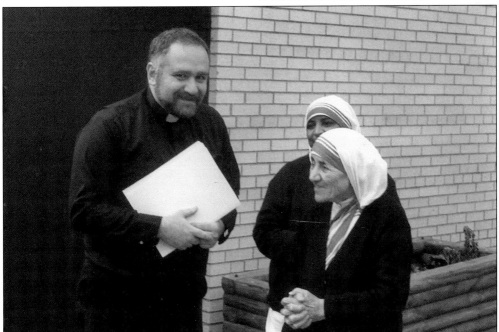

Mother Teresa established the Missionaries of Charity in Calcutta in 1950. She opened a convent in the South Bronx near St. Mary's Park more than 30 years ago, and the number of sisters in the borough has continued to grow. Among their facilities is the Queen of Peace Home, a shelter for men, on East 146th Street. Mother Teresa made many visits to the Bronx during her lifetime, including the one shown here.

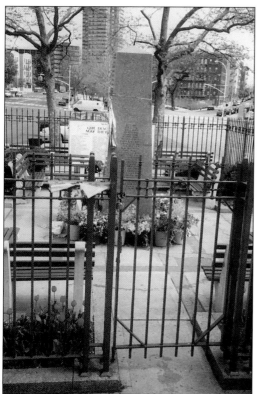

The Happy Land Monument is located on Southern Boulevard just north of East Tremont Avenue. It was erected to memorialize the 87 people who perished in the conflagration of March 25, 1990. Many of the victims were Hondurans, and the Federation of Honduran Organizations of New York now has an annual parade that passes in front of the memorial. (Photograph by Bill Twomey.)

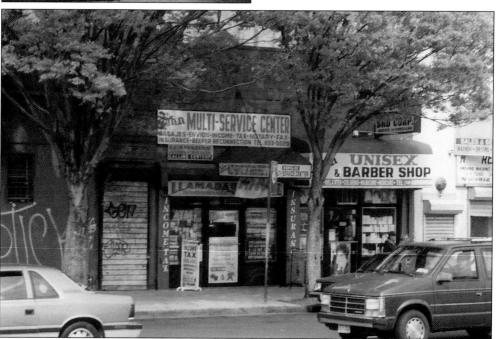

The site of the Happy Land fire was often adorned with floral arrangements until the 12-foot monument was erected on the traffic island across the street. The building is located at 1959 Southern Boulevard. (Photograph by Bill Twomey.)

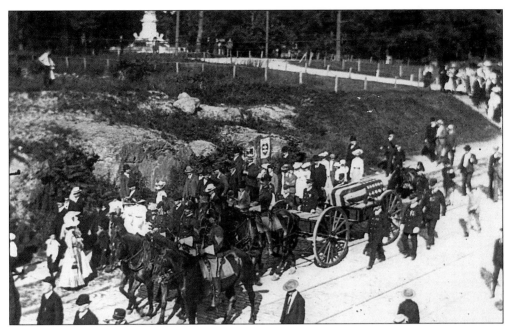

The Franz Sigel funeral procession is passing the Lorelei Fountain (upper left) at the Grand Concourse north of East 161st Street in this August 24, 1902 photograph. The 15.99-acre park extending south on the concourse from East 158th Street was later renamed for him. (Courtesy John McNamara.)

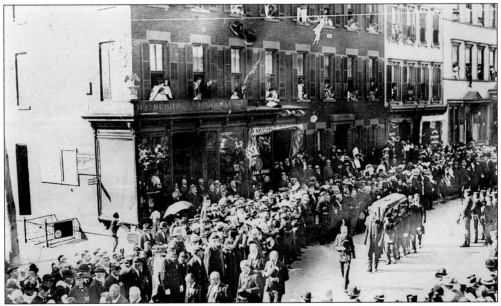

Franz Sigel, a Civil War general and newspaperman, was one of the most influential leaders in the German community until his death on August 21, 1902. His funeral was held from the Melrose Turn Verein Hall (upper right) because no funeral parlor was large enough to handle the thousands expected. It was one of the largest funeral processions held in the borough. This photograph was taken on August 24, 1902, at the northwest corner of Courtlandt Avenue and East 150th Street. (Courtesy John McNamara.)

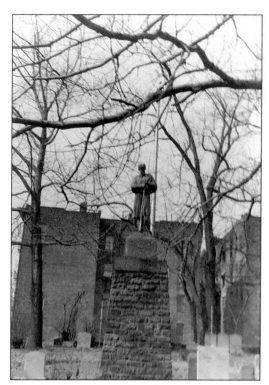

The Soldier Monument in the West Farms Soldier Cemetery appears without the rifle that was so much a part of the display. After the rifle was replaced a couple of times, it became apparent that any effort to replace it again would soon be met with another loss. This photograph was taken in 1952. (Courtesy John McNamara.)

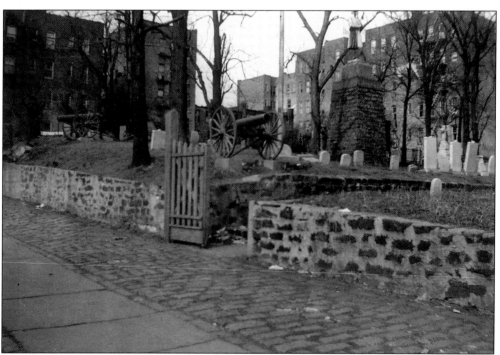

A fence did not enclose the West Farms Soldier Cemetery when the author was a young boy. It was hardly necessary, as young and old alike generally treated it with respect. This photograph was taken in 1952. Note the artillery piece in the center. (Courtesy John McNamara.)

This photograph is reminiscent of another era with the cobblestones on either side of the sidewalk adjacent to the West Farms Soldier Cemetery. The cemetery was established in 1814, and this picture was taken in 1952. (Courtesy John McNamara.)

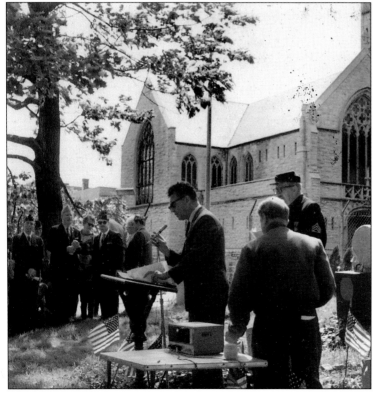

Bert Sack often presided at ceremonies at the West Farms Soldier Cemetery. He can be seen at the right rear in this May 1969 picture. Ted Schliessman and John McNamara were also on hand for the Memorial Day celebration. (Courtesy John McNamara.)

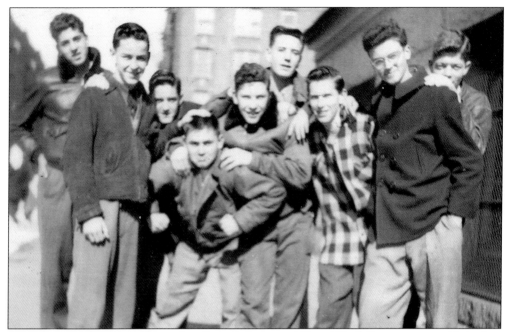

St. Simon Stock Church, located at Ryer Avenue and East 182nd Street, was established in 1920. Some parishioners still return to process through the neighborhood streets on Good Friday. These young men are posing outside the church in 1947. They are, from left to right, Danny Lyons, Richie Looney, Romey Brady, Monk Morris, Joe O'Donnell, unidentified, Tommy Leavey, Tony Amato, and Rich Kiernan. (Courtesy Ernie Braca.)

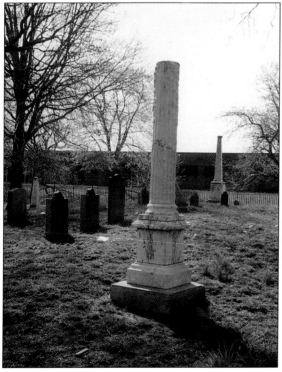

Joseph Rodman Drake Park is actually an old cemetery at Oak Point and Hunts Point Avenues. It was named for "the Poet of the Bronx," who requested that he be buried by the Bronx River, where he wrote so many of his poems. He was also a medical doctor and died in 1820 at the age of 25. (Photograph by Bill Twomey.)

Three

SCHOOL DAYS

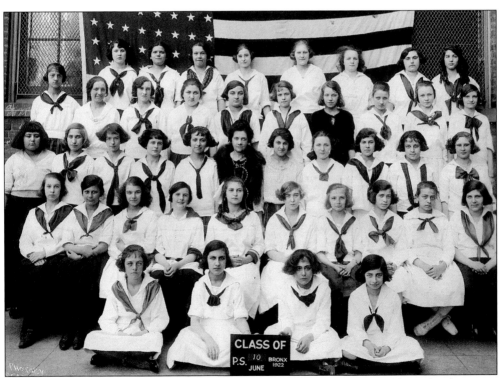

There are 42 girls plus their teacher in this 1922 class picture from Public School No. 10. Almost all the girls are wearing a neckerchief, and the teacher is wearing a fur stole. The photograph was taken in front of the school, located at the southeast corner of Eagle Avenue and East 163rd Street. The sprawling building faced Eagle Avenue and was just across the street from the famed Schnorer Club. (Author's collection.)

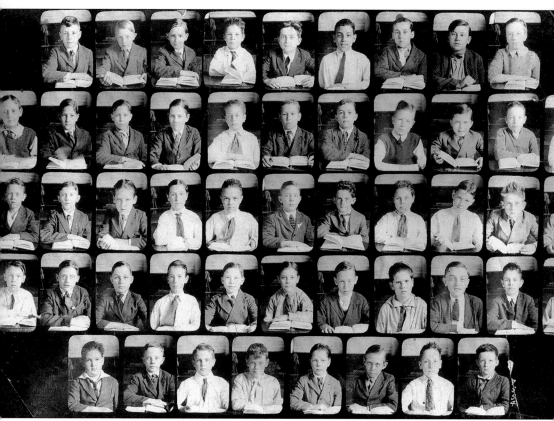

This 1922 photograph pictures the fourth-grade class of Immaculate Conception School. Starting at the bottom are, from left to right, the following: (first row) Francis Nash, James Tully, Edward Millmore, Charles McGinn, John McNamara, Michael Bostick, William Jantzen, and Francis Collins; (second row) William McCauley, Joseph Dunn, Joseph Helfrich, Joseph Finneran, Walter Schwartz, Lawrence Shanahan, Joseph Saldis, Charles Frey, Edward Lyon, John Kunzelman, and George Mulvihill; (third row) James Leonard, Harold Dunn, Francis Markert, Louis Caggiano, James Stewart, Francis Burckhart, Leo Nagle, William Krumm, George Foster, Frank Nagle, and Fred Gmuer; (fourth row) Joe Baumann, Thomas Daddario, Albert Windorf, William O'Rourke, Joseph Menge, Leo Winter, Thomas Rafferty, Joseph Kilcullen, Raymond Jackson, James McLaughlin, and Ferdinand Wink; (fifth row) Thomas Doris, Francis Bott, Henry Gmuer, Wilfred Steiniger, Felix Toner, James Judge, Charles Dilg, John Mertz, and John Sexton.

It is interesting to note that the German language was a required subject during this era at this school. It would not have been evident, judging by the good number of Irish surnames recorded here. The school is located at East 151st Street west of Melrose Avenue. (Courtesy John McNamara.)

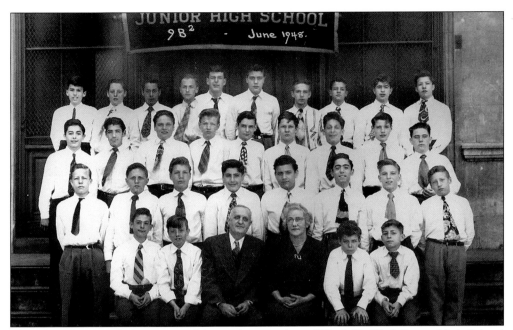

This class photograph shows part of the graduating class of Elijah D. Clark Junior High School (Public School No. 37) in June 1948. The principal, Benjamin Strumpf, and class teacher, a Miss Fitzpatrick, are in the front row, center. The main entrance to the school is on East 145th Street just east of Willis Avenue, but the building extends back to East 146th Street, where this picture was taken. The school has since moved to Willis Avenue, but this building was preserved and converted to condominiums. (Courtesy Bill Armstrong.)

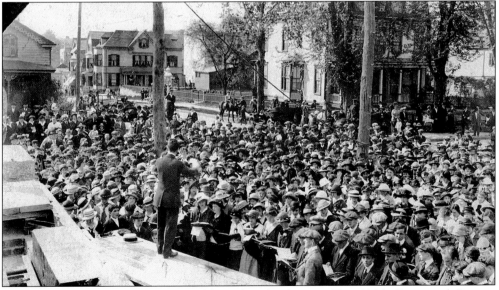

The original location of Evander Childs High School was at East 184th Street and Creston Avenue. Taken on May 27, 1919, this photograph looks west. It shows the ceremonies surrounding the laying of the cornerstone. The man standing on the platform and facing the crowd is teacher Jerry Reynolds, who is leading the singing. The school has since relocated. (Courtesy John McNamara.)

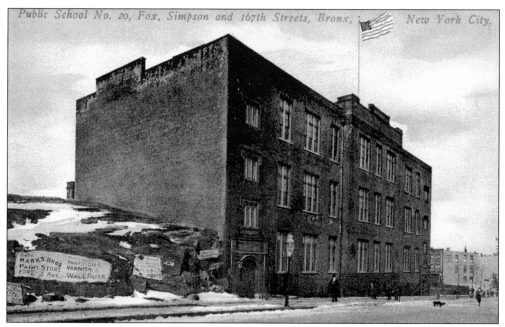

Public School No. 20, located on the south side of East 167th Street between Fox and Simpson Streets, proudly flies the American flag. Note the advertisements painted on the rocky outcropping at the left. The one farthest to the left touts Marks Brothers Paint Store on Third Avenue. The one farther right is a meat store advertisement. The last one is too small to read. (Courtesy Thomas Casey.)

When Public School No. 2 was built on Third Avenue, East 169th Street was not as yet cut through. The location is the east side of Third Avenue between East 168th and East 170th Streets. (Courtesy Thomas Casey.)

St. Thomas Aquinas School is located at 1909 Daly Avenue just north of the Cross Bronx Expressway. The school was established in 1906. (Photograph by Bill Twomey.)

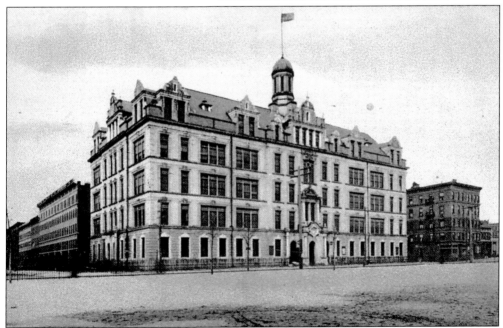

Public School No. 27 appears in a delightful setting with plenty of grounds around it. It was constructed on the west side of St. Ann's Avenue between East 147th and East 148th Streets. (Courtesy Thomas Casey.)

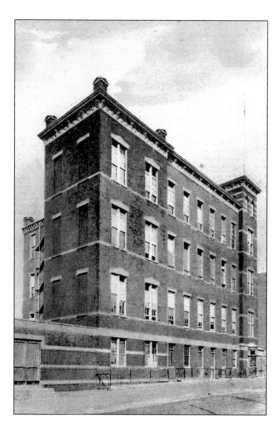

The red brick Public School No. 18 was built on the west side of Courtlandt Avenue between East 146th and East 148th Streets. (Courtesy Thomas Casey.)

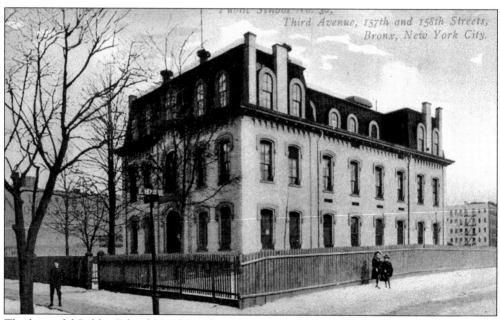

The beautiful Public School No. 76 is shown surrounded by a high wooden fence. The school was constructed on Third Avenue between East 157th and East 158th Streets. (Courtesy Thomas Casey.)

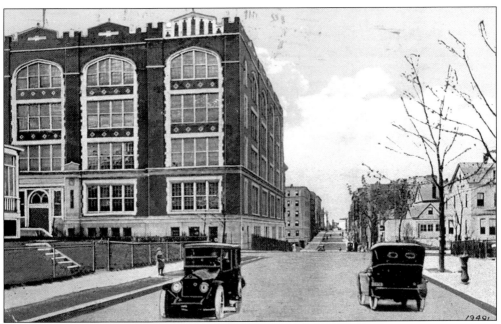

The vintage automobiles in this view of Public School No. 44 give the scene great nostalgic value. The school was erected at Prospect Avenue and East 176th Street. (Courtesy Thomas Casey.)

Arthur Seifert was revisiting his old neighborhood when this photograph was taken. Public School No. 51 is at the right, on the northeast corner of Trinity Avenue and East 158th Street. The view looks toward the north, and Morris High School can be seen in the distant background. (Courtesy Arthur Seifert.)

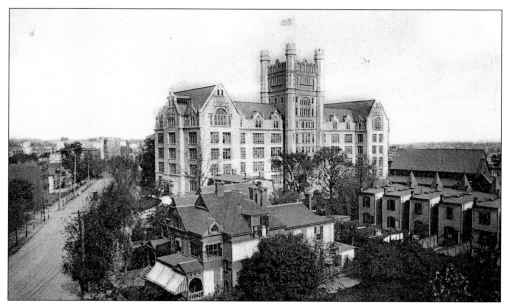

Morris High School was established in 1897 but did not move to this building at East 166th Street and Boston Road until 1904. It is one of the most beautiful high schools in the borough and has been designated a historic landmark. (Courtesy Thomas Casey.)

William Howard Taft High School has long been popular for sports, as can be seen from this baseball photograph. The school is located at 240 East 172nd Street.

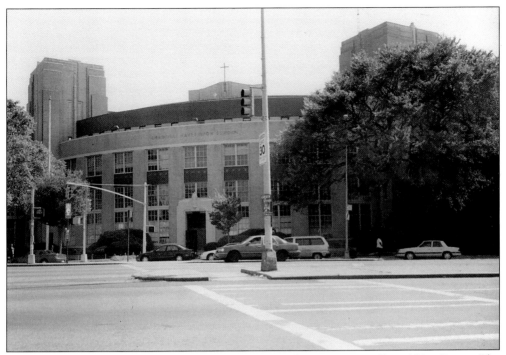

Cardinal Hayes High School is located on the Grand Concourse at East 151st Street. The cornerstone to this archdiocesan school was laid on November 20, 1940. It became an immediate success and today maintains one of the most sophisticated computer systems of any high school in the country. Msgr. John Graham is the current principal, and Regis Philbin is among the most noted graduates. (Photograph by Bill Twomey.)

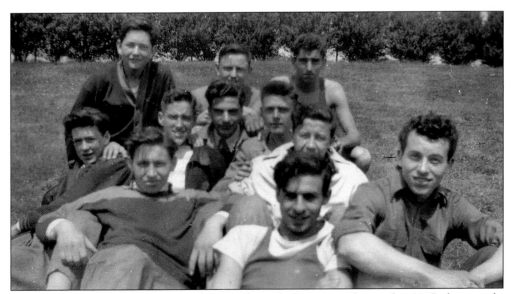

A group of Cardinal Hayes High School students find time to relax in this 1947 photograph. All are members of the same homeroom class. (Courtesy Jack Sauter.)

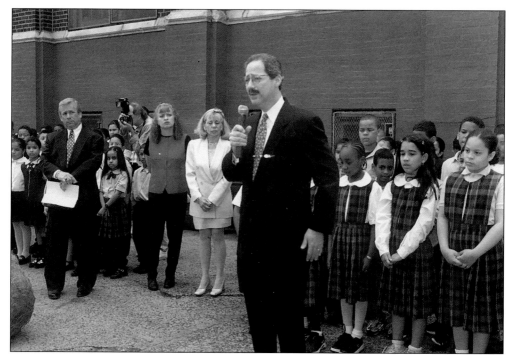

Bronx borough president Fernando Ferrer speaks to the students of CES 88 as they gather for a memorial tree-planting ceremony. The school is located at 1341 Sheridan Avenue at Marcy Place.

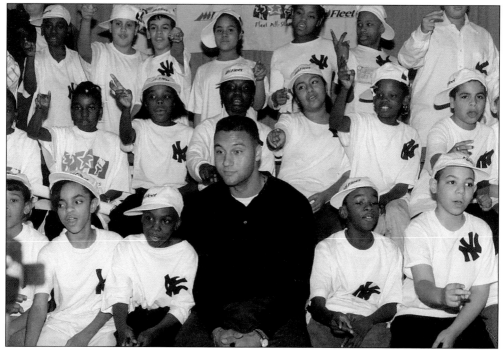

New York Yankee star Derek Jeter poses with the children of Public School No. 59 during a Fleet Bank All-Stars ceremony. The school is located at 2158 Bathgate Avenue.

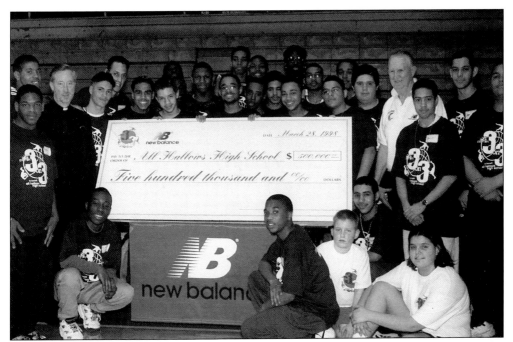

The students and staff of All Hollows Institute have a lot to smile about in this picture, as the check shown here is made out in the amount of $500,000. The school is located at 111 East 164th Street.

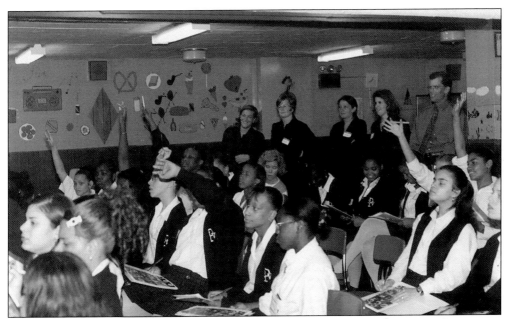

The girls in this photograph have reason to be animated and get their hands in the air. It is glamour day at St. Pius High School. Professionals from various disciplines stopped by to coach the girls on the latest glamour techniques. The school is located at 500 Courtlandt Avenue.

The Thomas C. Giordano Middle School 45, located at 2502 Lorillard Place, held its Arista installation ceremonies on April 8, 1998. Joseph Solanto, the principal, presided. David Silverman gave the opening remarks. Trung Bui, the Arista president, lit the first candle and led the pledging of the candidates.

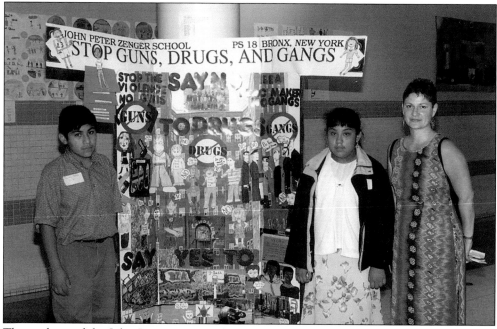

The students of the John Peter Zenger School (Public School No. 18), located at 502 Morris Avenue, gathered to say no to drugs, guns, and gangs.

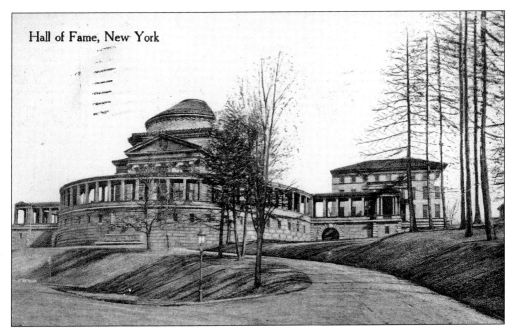

Hall of Fame, New York

The Hall of Fame for Great Americans was dedicated on May 30, 1901, by the president of New York University. High on a hill, the location afforded a grand view of the Harlem and Hudson Rivers and surrounding countryside. This grand edifice was taken over by Bronx Community College in 1973. (Courtesy Thomas Casey.)

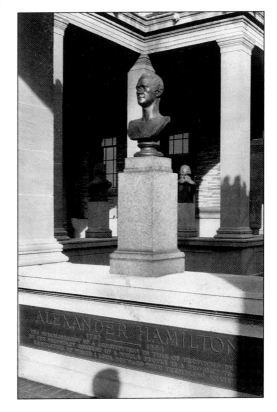

This bust of Alexander Hamilton is one of the many busts adorning the Hall of Fame for Great Americans. Each person honored had to be elected by a board of 100, and Hamilton was chosen in 1915. He is now joined by 101 other great Americans. The hall also contains 29 tablets designed by Tiffany. This picture was taken in 1931. (Courtesy John McNamara.)

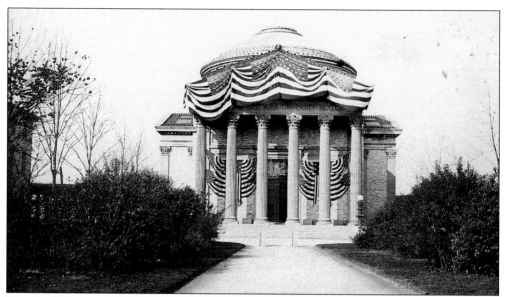

The Gould Memorial Library has become more popularly known as the New York University Library. It was designed by Stanford White and is one of the most beautiful structures in the Bronx. It was placed on the National Register of Historic Places in 1966. (Courtesy Thomas Casey.)

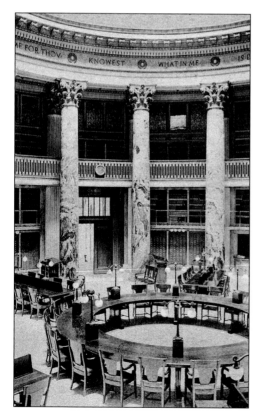

This is a grand early view of the interior of the library. The beautiful columns seen here were made of green Irish marble and support the dome. (Courtesy Thomas Casey.)

Four

CHANGING SCENES

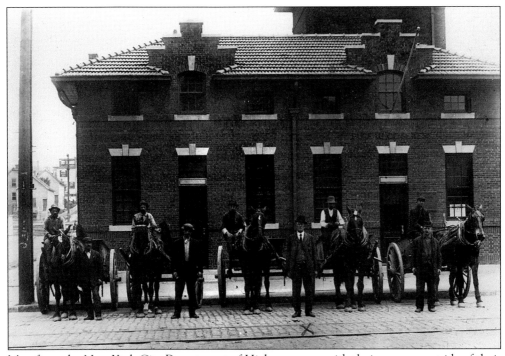

Men from the New York City Department of Highways pose with their wagons outside of their headquarters on the east side of Webster Avenue at East 180th Street. The foreman out in front (where the X is marked on the ground) is Fred Schailfelberger. The picture was taken in 1910. (Courtesy John McNamara.)

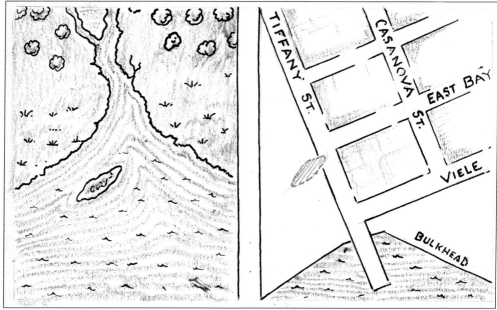

Bronx historian John McNamara drew these two sketches of Long Rock, which is also known as Duck Island. The one at the left shows its position when it was an island, and the drawing at the right shows its approximate location after the area was filled in. (Courtesy John McNamara.)

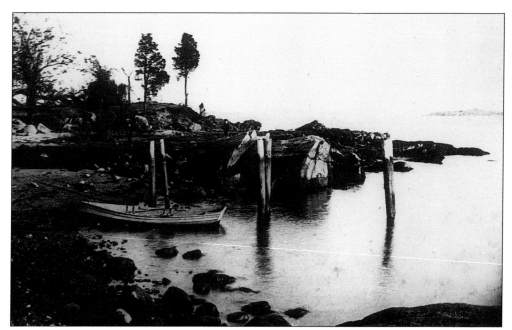

This photograph of Duck Island (also known as Long Rock) was developed from a glass plate. It was taken on Oak Point in 1888. The area (now known familiarly as La Playita) is the scene of Latin dancing and family barbecues during the warm weather. (Courtesy John McNamara.)

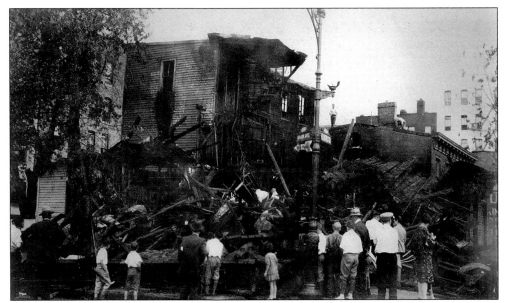

The first post office of Morrisania was once housed in this building, which was erected in 1850. It was the local grocery store, and the grocer, John Myrick, became the first postmaster. Thomas Blauvelt bought it after the Civil War for use as a restaurant. It then became a stationery store and bookstore operated by a Mr. Biefield. Still later, it became the Fischer Hotel of the 1890s.

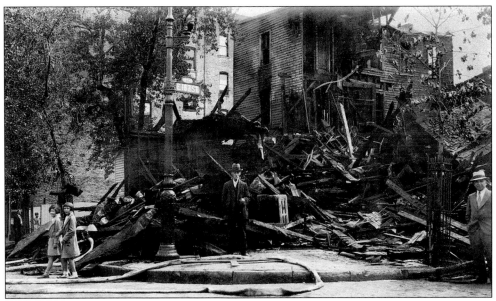

The building was home to the Tackamuck Democratic Club when it burned down in 1936. The firemen must still have been on the scene when this picture was taken, since the fire hose can be seen in the foreground. The building was located at what is now the northwest corner of East 167th Street and Park Avenue. (Courtesy John McNamara.)

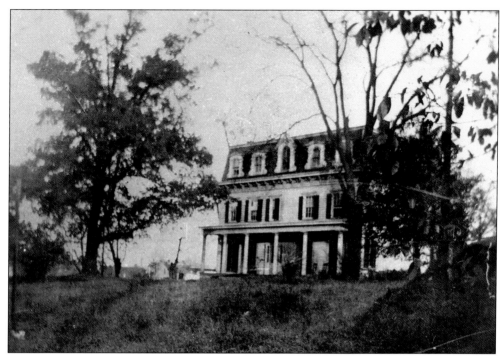

Thomas Minford built this fine old mansion on the east side of Boston Road not far from the junction of Southern Boulevard. The family had a large estate, which extended north to today's West Farms Square. Minford Place is a reminder of this early settler of the area. The Bolton family rented the building in the 1830s. (Courtesy John McNamara.)

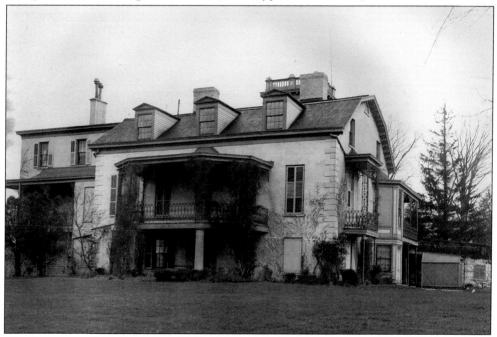

The Gouverneur Morris mansion was located where the railroad yard is today, at approximately East 132nd Street and Cypress Avenue. It was razed in 1906. (Courtesy Arthur Seifert.)

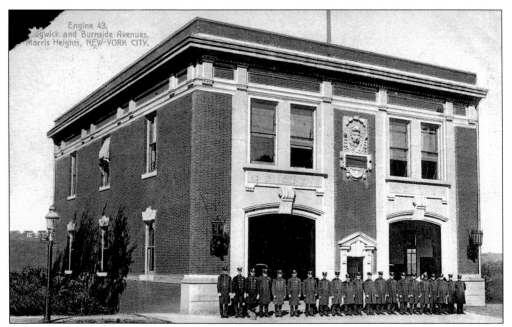

The members of an early fire company are shown here in front of their firehouse, Engine 43, located at Sedgwick and Burnside Avenues. (Courtesy Thomas Casey.)

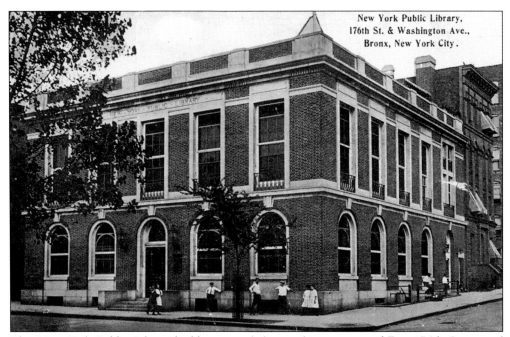

This New York Public Library building graced the northeast corner of East 176th Street and Washington Avenue just opposite the Trinity Congregational Church. (Courtesy Thomas Casey.)

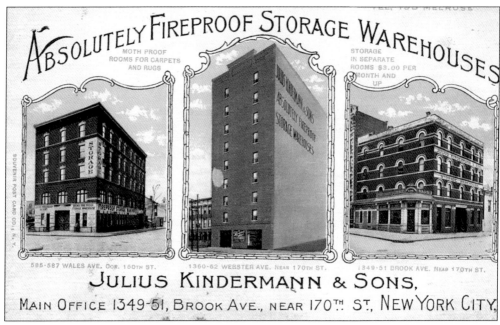

This advertising card showcases the three storage warehouses of Julius Kindermann & Sons. The one at the left was located at 585–587 Wales Avenue at East 150th Street, and the center one was at 1360–1362 Webster Avenue near 170th Street. The one at the right was at 1349–1351 Brook Avenue off East 170th Street, and this building also served as the company's headquarters. (Courtesy Thomas Casey.)

The American Real Estate Company (ARECO) was responsible for the development of a number of apartment houses in the South Bronx. This one is at the corner of Westchester Avenue and Simpson Street. Someone must be moving in or out in this photograph as a storage van is backed up to the curb. (Courtesy Thomas Casey.)

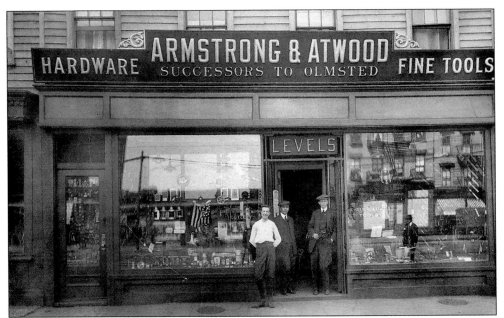

This hardware store, located at 2582 Third Avenue, was one of the longest-lived small businesses in the Mott Haven section. It was established in 1872 and continued in business until 1972. The youngster in the white shirt is Joseph Armstrong, who in 1940 took over the business from his father, Jacob Armstrong. Jacob is standing at the right of the doorway, and his partner at the time, a Mr. Atwood, is next to Joseph. The picture was taken c. 1918. Several years later Armstrong bought out Atwood.

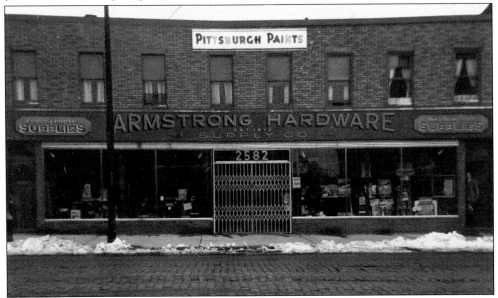

The same store as above is shown in this photograph taken on March 20, 1949. The store had been greatly enlarged and now also distributed machine tools and other industrial supplies to such institutions as the American Bank Note Company, R. Hoe & Company, and Gerosa Haulage Corporation. The family lived above the store until they moved to Throggs Neck in 1956. (Courtesy Bill Armstrong.)

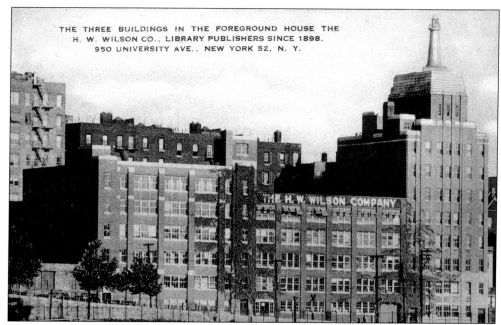

The H.W. Wilson Company was a noted library publisher since 1898 and occupied these spacious buildings, located at 950 University Avenue. Note the lighthouse on top of the building at the extreme right. It is still there and has become a landmark in the Highbridge community. (Courtesy Thomas Casey.)

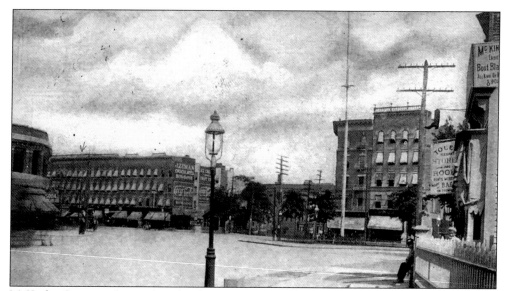

McKinley Square is featured in this fantastic photograph. What makes it special is the vintage light pole in the center and the wooden picket fence at the right. The sign at the top right is a bootblack advertisement. On the building in the background (to the left of the lamppost) are advertisements. The one on top is for J. Zeman Chocolates and bon-bons, and below that is a Coca-Cola advertisement. This square, located at East 169th Street and Boston Road, was a major intersection. The scene should bring back many fond memories to old-timers. (Courtesy Thomas Casey.)

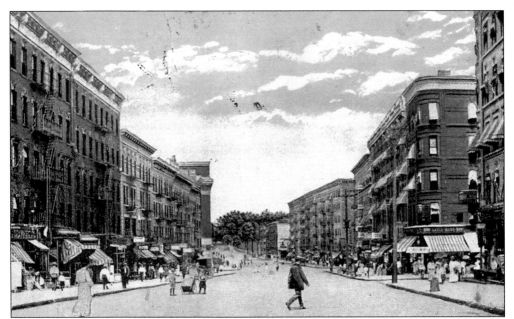

Shoppers came from all corners of the Bronx to shop on Bathgate Avenue, where many bargains could be found. This scene depicts Claremont Parkway and Bathgate Avenue. Note the old-style canvas awnings providing shade for the merchants and shoppers. (Courtesy Thomas Casey.)

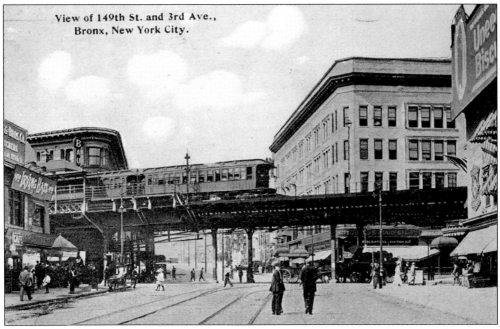

This is a magnificent view of East 149th Street and Third Avenue. Long known as the Hub, it was the shopping center for thousands and still draws considerable crowds. Note the Uneeda Biscuit sign on the building at the extreme right and the elevated line, which dominates the scene. The sign at the left is for Irving Hats. During this era, every man, young and old, covered his head in public. (Courtesy Thomas Casey.)

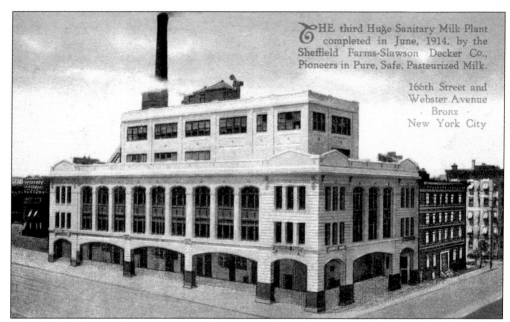

This Sheffield Farms-Slawson Decker Company Milk Plant was completed in June 1914. It had a capacity to process 200,000 quarts of bottled pasteurized milk in eight hours. Homogenized milk was not yet offered, and consumers had to shake the bottle before using it, as the cream would settle at the top. This plant was very modern and even offered tours of the facility, located at East 166th Street and Webster Avenue. (Courtesy Thomas Casey.)

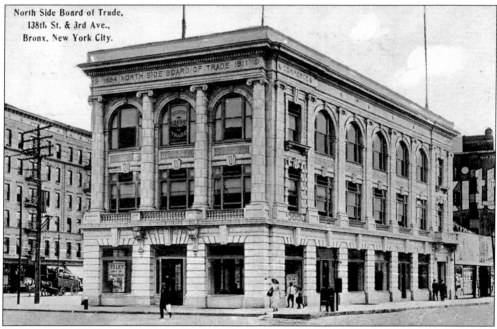

The North Side Board of Trade was organized on March 6, 1894, to obtain public improvements for the area. Mayor William J. Gaynor laid the cornerstone to the building shown here on October 28, 1911. The location is East 137th Street and Third Avenue. (Courtesy Thomas Casey.)

The Mapes House, located at the northwest corner of East 179th Street and Boston Road, was razed in the summer of 1968. The family ran a general store at 1920 West Farms Road and is also recalled for the Temperance House they established. This photograph was taken in 1963. (Courtesy John McNamara.)

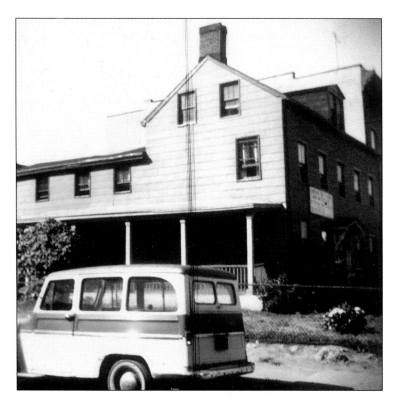

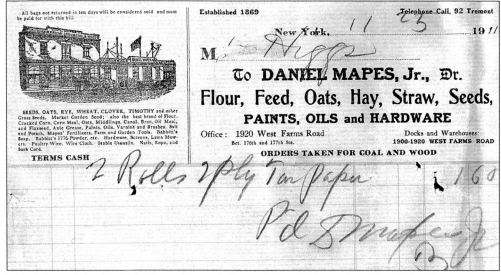

This billhead for Daniel Mapes General Store is dated November 23, 1911. The store was located at 1920 West Farms Road between East 176th and East 177th Streets. The bill is for two rolls of two-ply tarpaper, and the cost was $1.60. It is signed "Pd D Mapes Jr." This was among the largest businesses in the area. The company also maintained a warehouse at its Bronx River dock. (Courtesy Arthur Seifert.)

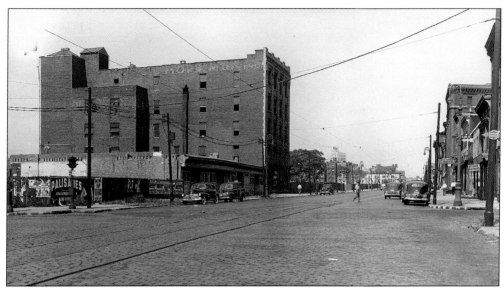

A grand expanse of open roadway is shown in this magnificent 1948 photograph. Note the cobblestones and the trolley tracks. The view is to the north on Third Avenue from East 139th Street. The site at the left is being cleared for the construction of the Lester Patterson Houses. Work began c. 1947 and was completed in 1951. (Courtesy Bill Armstrong.)

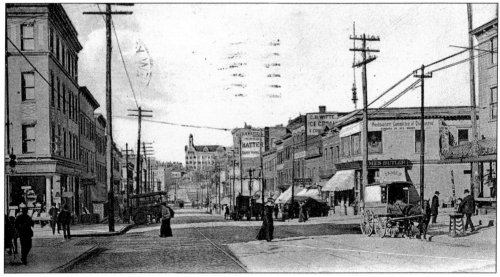

This view, looking west from Third Avenue, shows East Tremont Avenue in the first decade of the 20th century. It must have been a windy day, as the woman in the center is holding her hat. There are a number of old signs, such as those at the right for a hatter and for C.H. White Ice Cream. The sign on the building at the right reads, "Headquarters Committee of One Hundred, Borough of the Bronx." The horses, the carts, and the clothing offer a splendid view of this delightful era. (Courtesy Thomas Casey.)

Pictured is the Smith and Haffen Building, located at the junction of East 148th Street and Third and Willis Avenues. The view is to the south. Willis Avenue is at the left, and Third Avenue is at the right. The sign on the top of the building advertises an important tenant, the Knickerbocker Trust Company. Note the Third Avenue elevated line at the right and the beautiful cobblestoned roadway. (Courtesy Thomas Casey.)

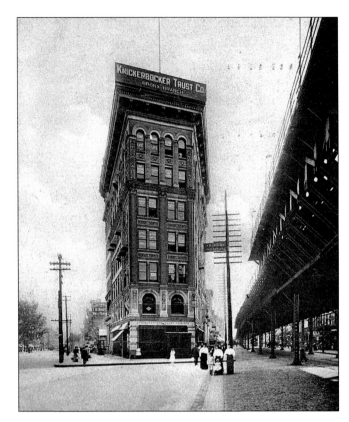

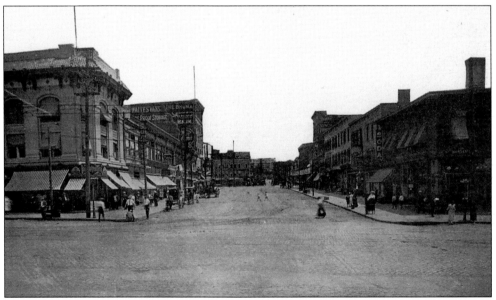

Looking east from Webster Avenue, this photograph offers an interesting view of East Tremont Avenue. It is a summertime scene, and the men are sporting straw hats, which were popular in the early 20th century. The advertisements on the buildings include one for the Bronx Savings Bank and one for Waites Vans and Fireproof Storage. (Courtesy Thomas Casey.)

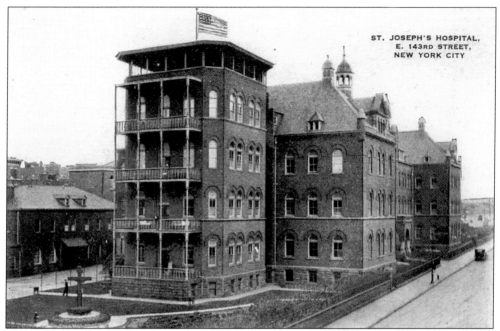

St. Joseph's Hospital was established in 1882 under the care of the Sisters of the Poor of St. Francis. Its primary mission was the care of tuberculosis patients, and it had a capacity of 400 beds. The entrance was on East 143rd Street, and the building extended north to East 144th Street between Brook and St. Ann's Avenues. (Courtesy Thomas Casey.)

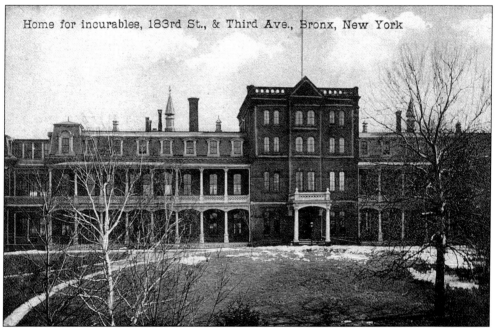

The Home for Incurables opened on 10 acres in 1866 on Third Avenue between East 181st Street and East 184th Street. The original capacity was 280 beds. St. Barnabus Hospital would later replace it. (Courtesy Thomas Casey.)

70

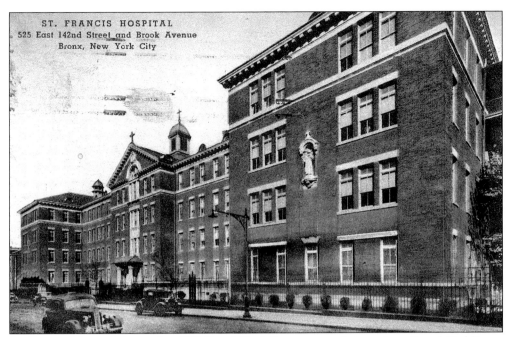

St. Francis Hospital, located at 525 East 142nd Street, extended north to East 143rd Street between Brook and St. Ann's Avenues. (Courtesy Thomas Casey.)

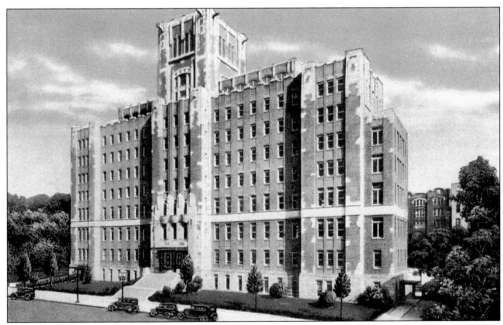

The Bronx Hospital and Dispensary was established in 1911, and this building opened in 1932. Located at Fulton Avenue and East 169th Street, it is now the Bronx-Lebanon Hospital. (Courtesy Thomas Casey.)

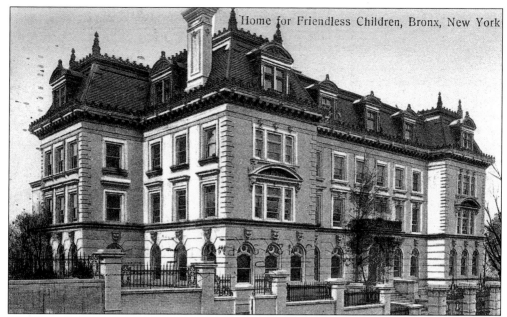

The Home for Friendless Children opened in 1902 on Woodycrest Avenue at East 161st Street. The American Female Guardian Society occupied another building in this vast complex just opposite McCombs Dam Park. (Courtesy Thomas Casey.)

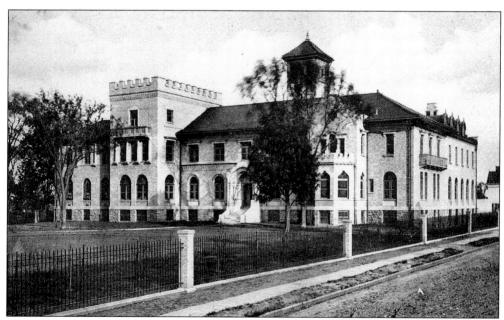

This is a grand view of the Sevilla Home for Children. The location is on the east side of Lafayette Avenue between Barretto Street and Manida Street in Hunts Point. The Corpus Christi Monastery is just across the street. (Courtesy Thomas Casey.)

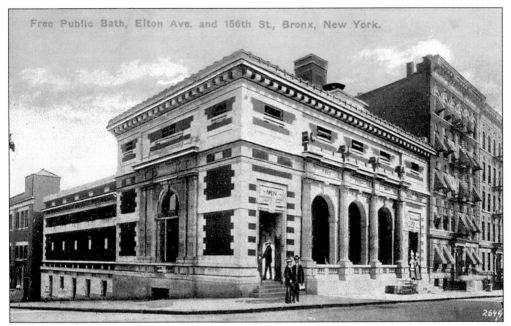

Free public baths are certainly a thing of the past, but they were immensely popular at one time. This one was located at the southeast corner of Elton Avenue and East 156th Street. (Courtesy Thomas Casey.)

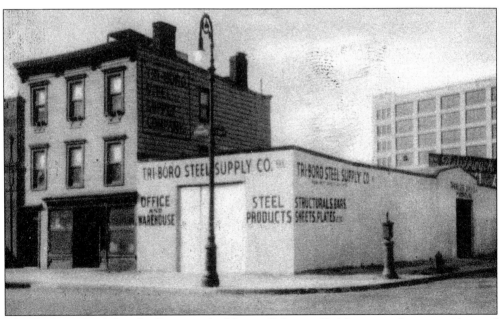

The Tri-Boro Steel Supply Company building will be recalled by many former residents of Mott Haven. Located at 133–135 Lincoln Avenue, it was operated by Herman C. Dornheim. (Courtesy Thomas Casey.)

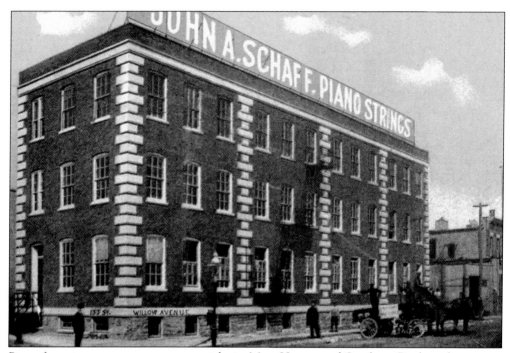

Piano factories were once a common sight in Mott Haven, and Southern Boulevard was once known as "piano row." The John A. Schaff Company specialized in piano strings and was located at the northwest corner of East 133rd Street and Willow Avenue. (Courtesy Thomas Casey.)

The piano-manufacturing headquarters of Strich & Zeidler occupied this building at 79 Alexander Avenue between East 132nd Street and Southern Boulevard. Many such factories could be found throughout the South Bronx in the early decades of the 20th century. The Kroeger Piano Factory and the Behning Piano Company occupied contiguous sites to this building. (Photograph by Bill Twomey.)

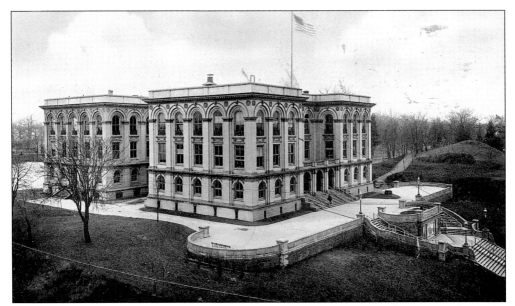

This prominent edifice, designed by George B. Post, opened in 1897 and served as the Bronx Municipal Building. It was located at the northwest corner of Crotona Park at East Tremont and Third Avenues. The beautiful stairway led down to Third Avenue and is still there, but the building was razed after being gutted by a fire in April 1968. (Courtesy Thomas Casey.)

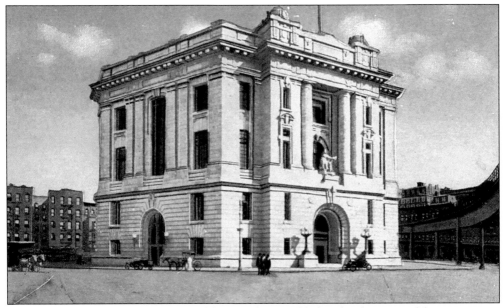

The Beaux-Art style of construction of this courthouse added to the character of the community, but the structure took a full decade to erect. Construction began in 1904, but the cornerstone was not laid until 1911. The building was completed in 1914, and questions arose about the final cost of construction. The location is Third Avenue at East 161st Street. (Courtesy Thomas Casey.)

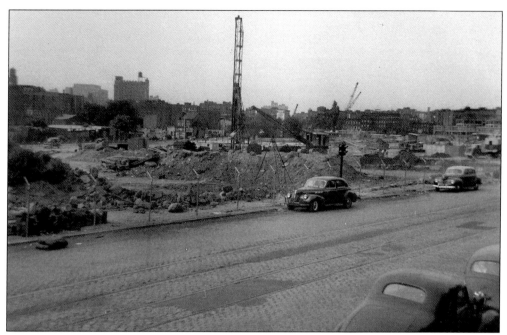

This photograph, taken on June 29, 1949, shows the Lester W. Patterson Houses under construction. Note the pile driver in the center. The location is the west side of Third Avenue, north of East 139th Street. (Courtesy Bill Armstrong.)

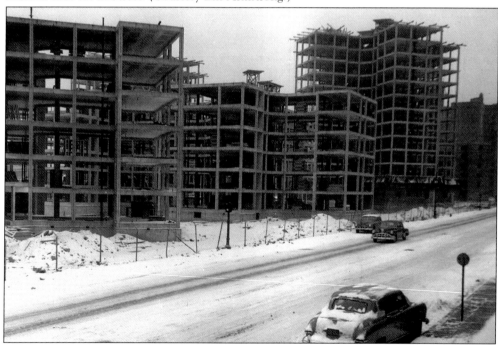

Construction continues on the Lester Patterson Houses in this photograph taken on February 20, 1950. Note the snowy weather and the clean area at the right around the bus stop. Special crews were assigned snow-shoveling duty during these years to maintain the safety of the bus passengers. The view is northward on Third Avenue from East 139th Street. (Courtesy Bill Armstrong.)

Five

BREWERIES

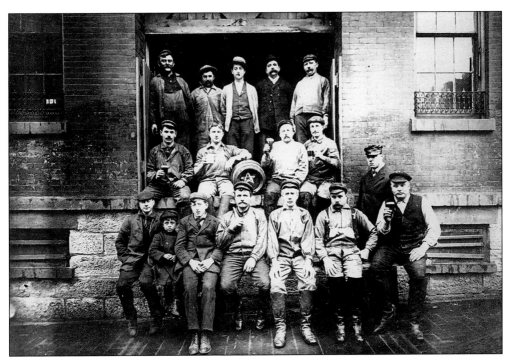

The Haffen Brewery operated from 1856 to 1917 and was a landmark in old Melrose. It was located on Melrose Avenue between East 151st and East 152nd Streets. This photograph of some of the employees was taken c. 1896. (Courtesy John McNamara.)

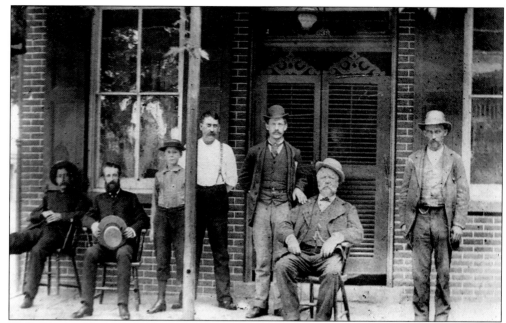

In this c. 1886 photograph, Matthias Haffen is seated in front of Protection Hall, at the northwest corner of East 152nd Street and Courtlandt Avenue. His second son, Henry, is standing to the left, wearing a white shirt, while his youngest son, Louis, is seated second from the left. The young boy between the two brothers is 14-year-old John Haffen. (Courtesy John McNamara.)

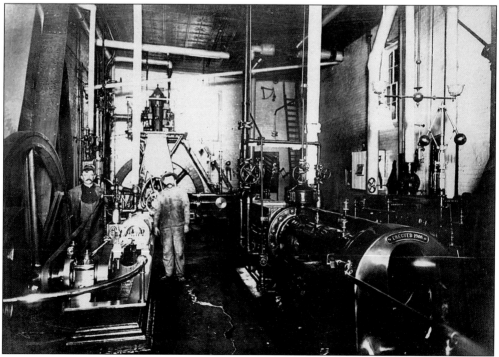

This photograph of the engine room of Haffen's Brewery was taken c. 1910. (Courtesy John McNamara.)

Henry Haffen, the brewer, is standing at the right in front of his home located at 306 East 163rd Street. Haffen's first wife, Mathilda (née Stoller), took the picture c. 1897. Her parents are standing at the left in the adjoining house. (Courtesy John McNamara.)

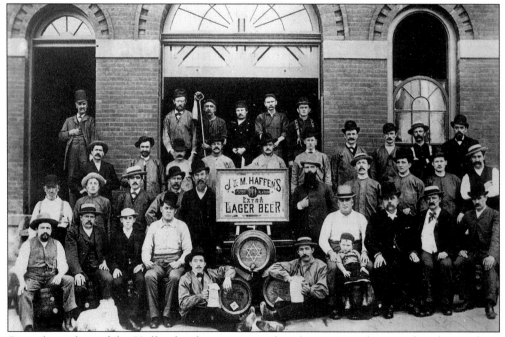

Several members of the Haffen family are portrayed in this c. 1896 photograph, taken in front of the brewery. John Haffen is seated fourth from the left and is wearing a black derby and white shirt. Louis is standing to the right of the sign and has a long black beard. Martin is in front and to the right of Louis and has a boy on his lap. (Courtesy John McNamara.)

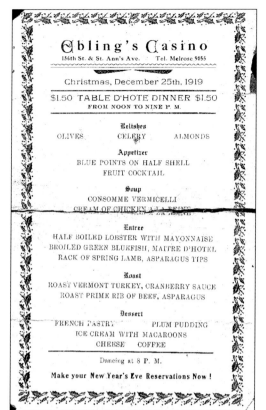

Ebling's Casino
156th St. & St. Ann's Ave. Tel. Melrose 9055

Christmas, December 25th, 1919

$1.50 TABLE D'HOTE DINNER $1.50
FROM NOON TO NINE P. M.

Relishes
OLIVES CELERY ALMONDS

Appetizer
BLUE POINTS ON HALF SHELL
FRUIT COCKTAIL

Soup
CONSOMME VERMICELLI
CREAM OF CHICKEN A LA REINE

Entree
HALF BOILED LOBSTER WITH MAYONNAISE
BROILED GREEN BLUEFISH, MAITRE D'HOTEL
RACK OF SPRING LAMB, ASPARAGUS TIPS

Roast
ROAST VERMONT TURKEY, CRANBERRY SAUCE
ROAST PRIME RIB OF BEEF, ASPARAGUS

Dessert
FRENCH PASTRY PLUM PUDDING
ICE CREAM WITH MACAROONS
CHEESE COFFEE

Dancing at 8 P. M.

Make your New Year's Eve Reservations Now !

Ebling's Casino was located on East 156th Street at Eagle Avenue and was attached to the brewery of that name. Various concerts, dances, and events were held there. This cardboard advertisement for the casino features a Christmas festival held on December 25, 1919. The cost was only $1.50. The casino closed during World War II. (Courtesy John McNamara.)

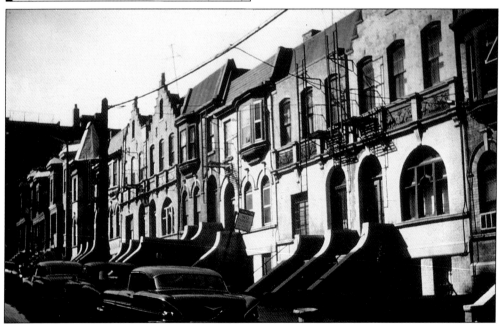

This photograph of "brewmaster's row" was taken in the 1980s. Many of the brewers chose to live near their work, and these houses on the east side of Eagle Avenue north of East 156th Street were home to some of them. (Courtesy John McNamara.)

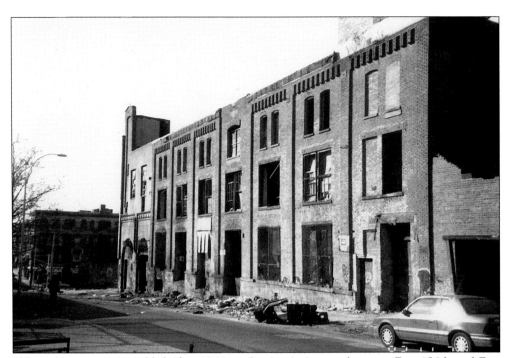

Ebling's Brewery was established *c.* 1868 on St. Ann's Avenue between East 156th and East 158th Streets. This recent view, looking southwest from Eagle Avenue, shows the back of the building. (Photograph by Bill Twomey.)

When this photograph of Ebling's Brewery was taken in 1993, it was long vacated and was used by vagrants as a shelter. Inside, they had a 55-gallon drum that they used for both heating and cooking. Note the initials *E* and *B* on the windows. The man standing in front of the building is Ronald Schliessman, the leading expert on Bronx breweries. The photograph, looking west, was taken from Eagle Avenue, south of East 158th Street. (Photograph by Bill Twomey.)

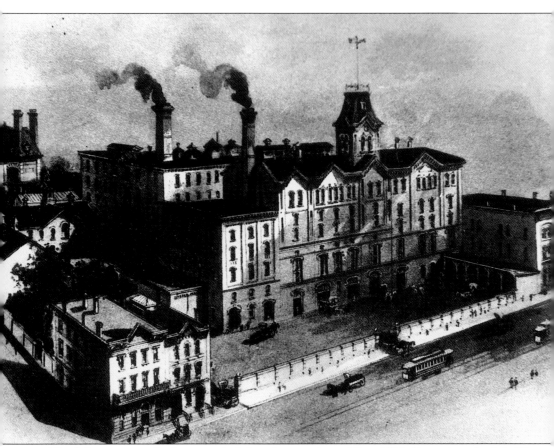

Third Avenue is in the foreground of this photograph, and East 169th Street is at the left. The massive complex shown is the John Eichler Brewing Company. John Eichler was born in Bavaria on October 20, 1829, and served apprenticeships in Rothenburg, Baden, and Berlin before coming to America. He arrived in New York at the age of 29 and soon found work with the Turtle Bay Brewery, which later became the Franz Ruppert Brewery. When he had enough savings, he formed a partnership and began working for himself. After buying out his partner, he managed to purchase the Kolb Brewery, which served as the genesis for the large complex seen here. John Eichler died on August 4, 1892, but the business remained in the family until Rheingold purchased it in 1947. It is interesting to note that Rheingold continued to use the Eichler label for several years thereafter, since it had become so popular. (Courtesy Ronald Schliessman.)

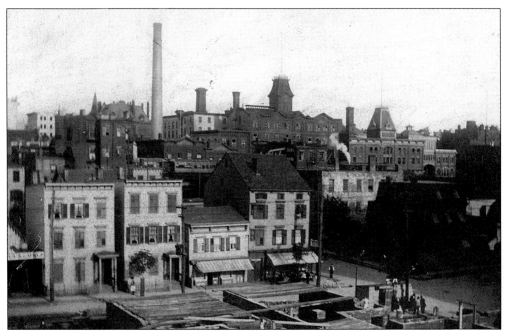

In this c. 1905 view looking east, Washington Avenue is in the foreground. The larger dark building in the center is the John Eichler Brewery, located on Third Avenue and East 169th Street. The property was later used to develop the Bronx Lebanon Hospital complex. (Courtesy Ronald Schliessman.)

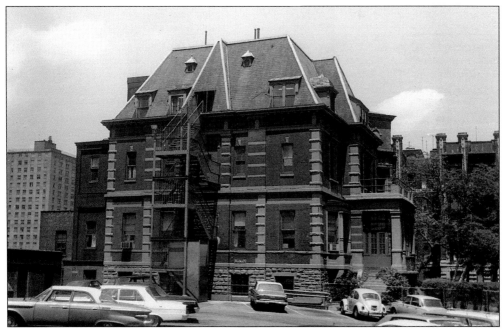

John Eichler, the Bavarian brewmeister, lived in this large mansion at the southwest corner of Fulton Avenue and East 169th Street. He did not have far to travel to work, as his brewery was right around the corner. (Courtesy Ronald Schliessman.)

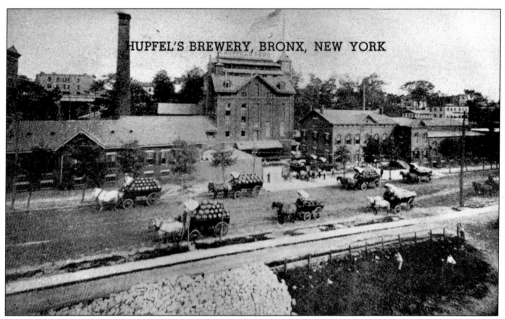

HUPFEL'S BREWERY, BRONX, NEW YORK

Anton Hupfel founded the Hupfel Brewery at St. Ann's Avenue and East 161st Street in 1865. It occupied the entire area from East 159th Street to East 161st Street and from St. Ann's Avenue to Eagle Avenue. It operated until Prohibition. This view dates from 1896. (Courtesy Bill Armstrong.)

Nº 14095

Driver No.

Telephone Melrose { 4888 4889

Brooklyn Warehouse Telephone Henry 3788

ANHEUSER-BUSCH ICE & COLD STORAGE CO., Inc.

164TH STREET & BROOK AVENUE

New York, 7/23 192 6

Sold to _Higgs Bead Com_

2	Cases, 2 doz. BUDWEISER			
	Casks, 10 doz. "			
	Cases, 2 doz. BEVO			
	CREDITS			
	Cases at 90c each			
	Doz. Bottles at 30c a doz.			
	Cases at 50c each			
	Doz. Bottles at 20c a doz.			
	CASH RECEIVED			

Received above

Per

THE SHELBY SALESBOOK CO., SHELBY, OHIO. 905-7)

Anheuser-Busch has become a big name in brewing. This bill for two cases of Budweiser beer is made out to Higgs Beach and is dated July 23, 1921. The Anheuser-Busch facility was located on the west side of Brook Avenue at East 164th Street between the Reinhart Company and the Slawson Decker Company. (Courtesy Arthur Seifert.)

Six

Entertainment and Recreation

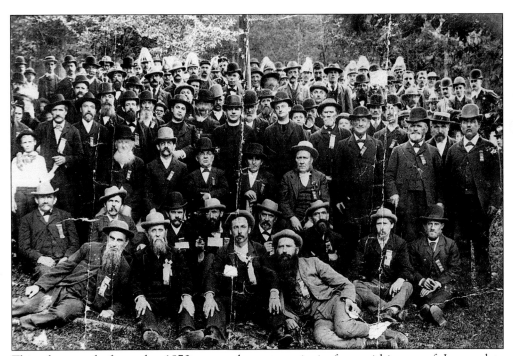

This photograph from the 1870s was taken at a picnic for parishioners of Immaculate Conception Church in Melrose. Members of the Melrose Guard are in the rear. Note the military headdresses. These guards were established by Louis Sauter to protect this church during some troubling times. (Courtesy John McNamara.)

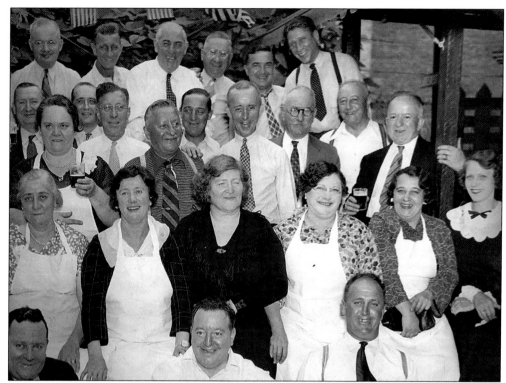

This photograph of a clambake was also taken at the Old Dutch Broadway Tavern, located at the southeast corner of East 150th Street and Courtlandt Avenue. It is dated September 13, 1936. (Courtesy John McNamara.)

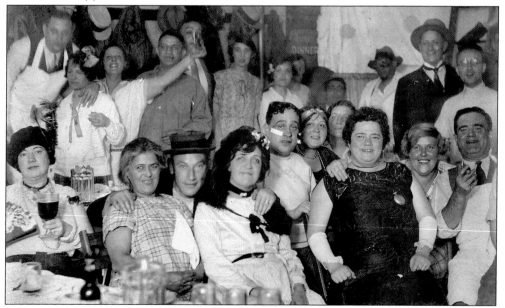

This photograph of festivities at the Old Dutch Broadway Tavern was taken c. 1929. John McNamara is seated at the right, and his wife, Betty, is at his side. Joe McCaffrey is standing third from the right with the hat, collar, and tie. (Courtesy John McNamara.)

Paul Daube operated one of the most popular steakhouses in the borough, and this card invites diners to his annual venison dinners to be held in January and February 1941. The popular eatery was located at 833 Courtlandt Avenue, and the cost of the dinner was $1.75 per person. The restaurant was located in an old wooden house, but the décor did not deter the crowds. Babe Ruth was among the celebrities who often dined here. (Courtesy John McNamara.)

You and your friends are cordially invited to attend

OUR ANNUAL VENISON DINNER

1941	JANUARY	1941
TUESDAY	WEDNESDAY	THURSDAY
28	29	30

1941	FEBRUARY	1941
TUESDAY	WEDNESDAY	THURSDAY
4	5	6
11	12	13
18	19	20

PAUL DAUBE

Famous for Steaks and Chops

833 COURTLANDT AVENUE

Bronx, New York

BY RESERVATION ONLY

Tel. MOtt Haven 9-8282

Charge $1.75 per Person *Call Early*

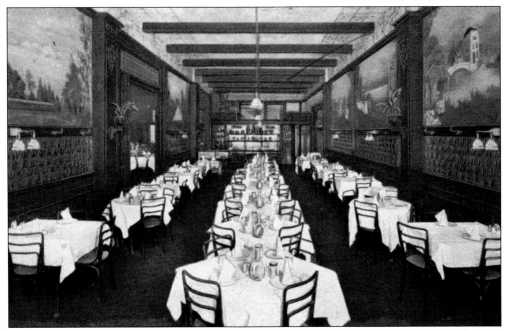

The Criterion Restaurant was located in the American Real Estate Company building, at 385–391 East 149th Street. It was conveniently located at the Third Avenue elevated, and many diners were attracted to the restaurant's evening music. (Courtesy Thomas Casey.)

Gebirgstrachten & Schuhplattler Verein "Weiss=Blau"

HANS BENZINGER, Praesident

MAY FESTIVAL AND DANCE — at — Hunts Point Palace 953 Southern Boulevard Bronx, N. Y. Saturday May 3, 1952 **ADMISSION** In Advance $1.25 At the Door $1.50	**Mai Fest und Tanz** SAMSTAG, den 3. MAI, 1952 — 8 Uhr Abends veranstaltet im **Hunts Point Palace** 953 Southern Boulevard Bronx, N. Y. **Bandl Tanz and Bayerische Volks Taenze** **Grosser Preisstand** **Massen Schuhplattler** **Unterhaltung in Huelle und Fuelle** **KARL WEISS ORCHESTER** Tickets $1.25 At the Gate $1.50 Reservations for Loges can be made in advance. HEADQUARTERS: Bronx Turn Hall, 412 East 158th Street (MEETINGS EVERY WEDNESDAY) Directions: Lex. Ave. Subway (Pelham Bay) to Hunts Point Rd. Lexington or Seventh Ave. to Simpson Street.

German clubs once abounded in the Bronx, and the Gebirgstrachten & Schuhplattler Verein was located at 412 East 158th Street. The club sent out this card to announce a festival and dance to be held on May 3, 1952, at the Hunts Point Palace. This popular catering hall was located at 953 Southern Boulevard and was one of the largest such facilities in the borough. (Courtesy Thomas Casey.)

It would be extremely difficult to find someone from the South Bronx who has not dined at Alex and Henry's. It was located at East 161st Street and Courtlandt Avenue and was one of the most popular restaurants and catering houses in the Bronx. Numerous weddings, showers, and banquets were held in one of its 10 rooms. (Courtesy Thomas Casey.)

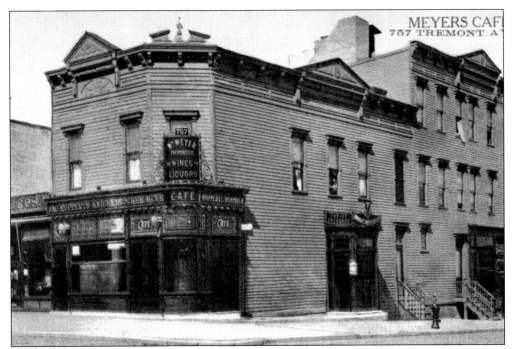

Meyers Café, located at 757 Tremont Avenue, specialized in imported wines and liquors. Note the family entrance door on Prospect Avenue on the right. (Courtesy Thomas Casey.)

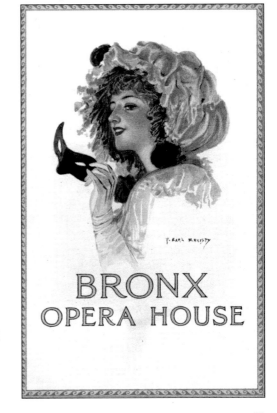

The cover shown here would be familiar to all Bronx theatergoers of the early 20th century. The Bronx Opera House was located at 436 East 149th Street near Third Avenue and was a major attraction at the Hub from 1913 to 1928. The covers of the opera house programs were generally the same. (Author's collection.)

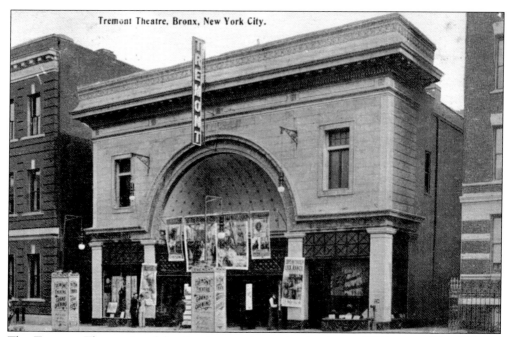

The Tremont Theatre is celebrating its grand opening in this *c.* 1910 scene. The 987-seat theater was located at 1942 Webster Avenue south of East 178th Street next to the New York Telephone Company Building. (Courtesy Thomas Casey.)

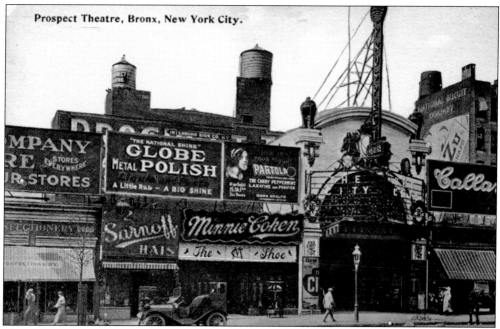

The Prospect Theatre was located at 851 Prospect Avenue. The layout was rather odd, as the theater itself was actually behind the buildings shown here. Note the narrowness of the entranceway that led to the theater. It was located north of Westchester Avenue between East 160th and East 161st Streets. It opened *c.* 1910 and had 1,600 seats. (Courtesy Thomas Casey.)

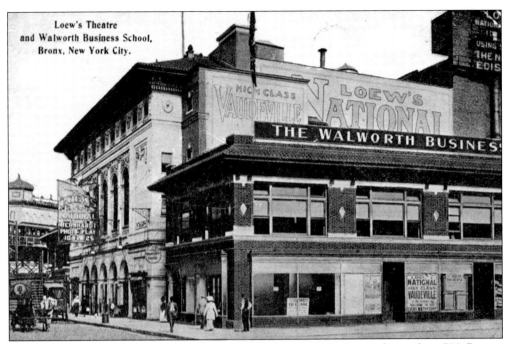

Loew's National was a rather large theater with 2,397 seats. It was located at 500 Bergen Avenue adjacent to the Walworth Business School. The location makes one wonder how many students cut classes to see the latest show. (Courtesy Thomas Casey.)

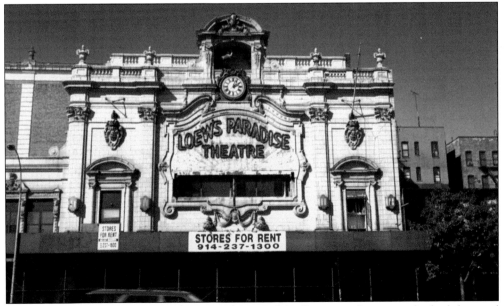

Loew's Paradise was the premier showcase theater of the Bronx, and anyone who had the good fortune of attending a show there will never forget it. From the plush carpet to the twinkling stars, it was magnificent in every way. It opened on September 7, 1929, with 3,884 seats and later expanded the capacity to 4,100. It became a multiplex in the 1970s. It is located on the Grand Concourse at East 187th Street, and the building is currently being renovated for use as a concert hall and perhaps even for boxing matches.

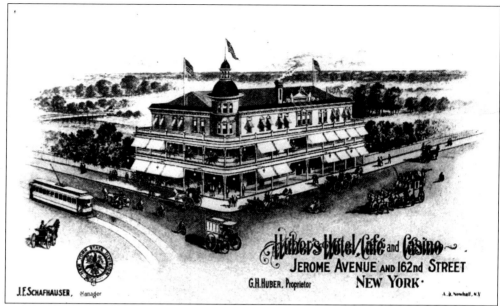

Huber's Hotel, Café and Casino was located at the northeast corner of East 162nd Street and Jerome Avenue. It faced East 162nd Street and extended east to Cromwell's Creek. This view dates from 1912. (Courtesy John McNamara.)

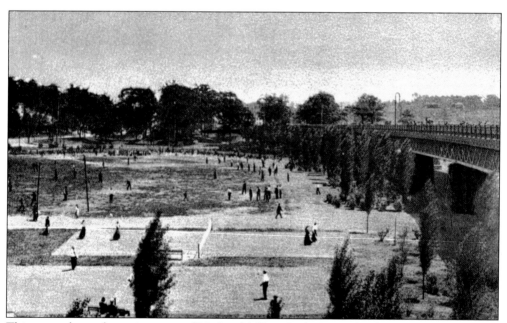

This scene shows the various uses of McComb's Dam Park. A couple of tennis matches appear to be in progress on the athletic field in the foreground. The park is located off East 161st Street near Yankee Stadium. (Courtesy Thomas Casey.)

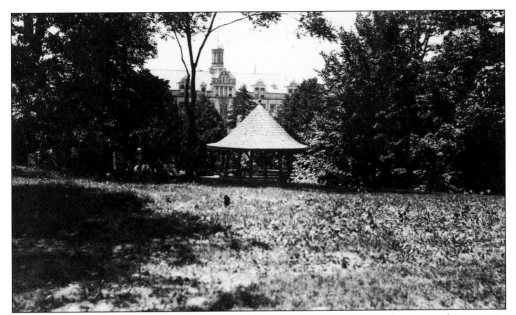

The bandstand erected by Louis Haffen when he was parks commissioner dominates this scene in St. Mary's Park. A freshwater pond had previously occupied the site. The view looks to the west toward St. Ann's Avenue, and Public School No. 27 is plainly visible in the background between East 147th and East 148th Streets. The picture was taken *c.* 1910. (Courtesy John McNamara.)

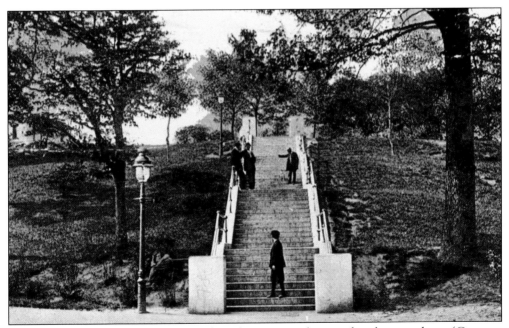

These steps in St. Mary's Park have long been a popular site for photographers. (Courtesy Thomas Casey.)

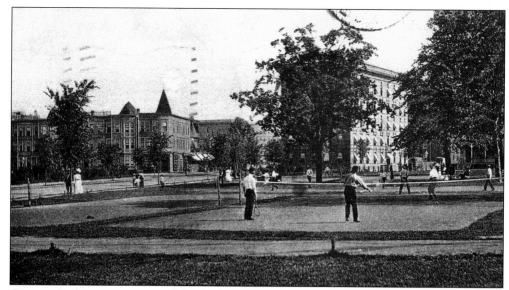

Crotona Park was once part of the Bathgate Farm. Alexander Bathgate had emigrated from Scotland and purchased the farm from his employer, Gouverneur Morris II. The park exceeds 150 acres and is noted for its beautiful trees and Indian Pond. The tennis courts are shown in this early scene. (Courtesy Thomas Casey.)

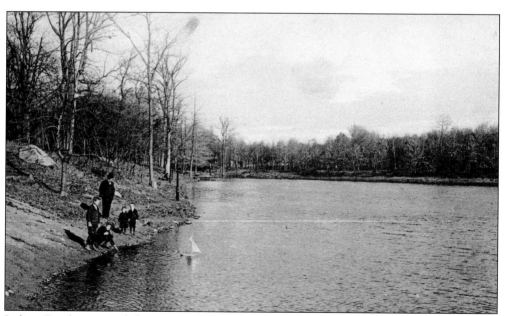

Indian Pond is one of the most popular features of Crotona Park. The Bronx Municipal Building, located at the northwest corner of the park at East Tremont and Third Avenues, was another focal point of the park. (Courtesy Thomas Casey.)

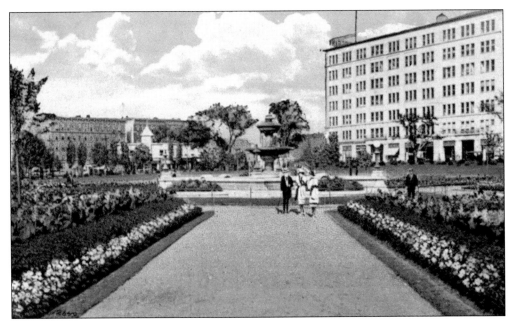

Victory Park, off East Tremont Avenue in Crotona Park, was a gorgeous area attracting numerous strollers from around the community, including some from the Bergen Building on Arthur Avenue, which is seen in the right background in this scene. (Courtesy Thomas Casey.)

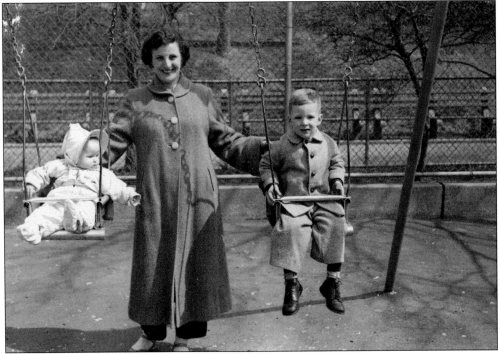

Ann McCarrick swings her children, Ann Marie (left) and Jackie (right), in one of the many play areas of Crotona Park. This photograph, looking east toward Arthur Avenue, was taken in 1956. The family lived on Washington Avenue, and Crotona Park was a frequent destination. (Courtesy Jack McCarrick.)

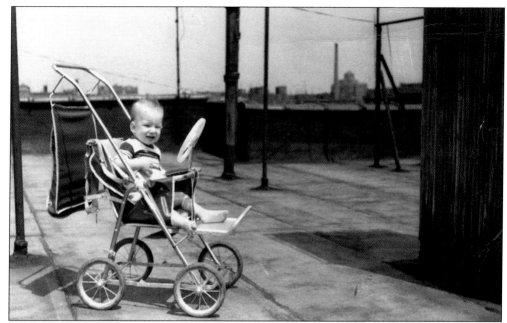

"Tar beach" is a familiar term to all South Bronx residents. The rooftop was an ideal locale for flying kites, playing games, or just for sunbathing. Some housewives would also set up racks to dry their clothing on hot summer days. A young Jack McCarrick is enjoying the sun in this 1954 photograph, taken atop 2028 Washington Avenue off East 178th Street. (Courtesy Jack McCarrick.)

The Schnorer Club of Morrisania was established in 1881 at East 163rd Street, east of Third Avenue. Soon, the most influential figures in Bronx society were attracted to the club, and it became a bastion of the Democratic party for 85 years. The club closed down on May 15, 1966. This photograph was taken in 1897 at the height of its popularity. (Courtesy John McNamara.)

John McNamara drew this picture, which he entitled "A Union Slugger of 1867." He tried to capture the look of the uniform of a popular ball team of the post–Civil War era. The Union ball field was located on Park Avenue and extended north from East 163rd Street in Morrisania. (Courtesy John McNamara.)

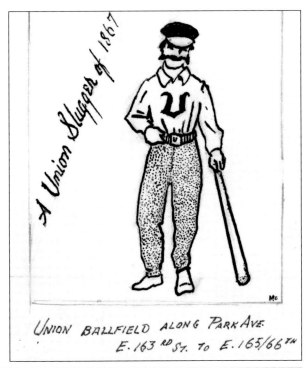

The Tackamuck Baseball Club was an outlet of the Tackamuck Democratic Club, which was located at East 167th Street and Park Avenue. George Lidner is at the rear left, and Edward Wilson Sr. (in the suit) is standing next to him. The next young man in uniform is Kenny Anderson. James J. Wilson is in the light-colored suit in the rear, second from the right. Red Hegarty is the youngster in the lower left. The manager of the team, Joe Bodnar, is third from the left in the front row. He has his arm around the shoulder of Paul Stewart. Fred Michelle is at the lower right. Most of the young men shown here were also members of the Teller Athletic Club. The picture was taken shortly before the club burned down in 1936. (Courtesy the Wilson family.)

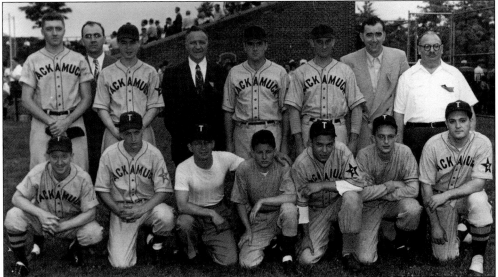

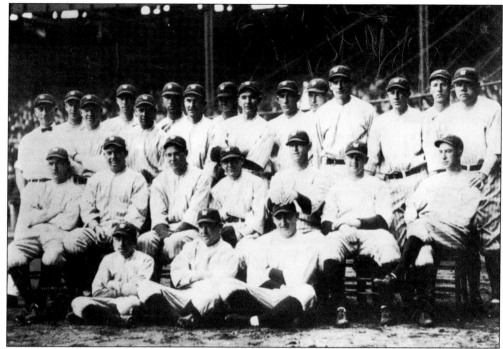

This photograph of the New York Yankees was taken in 1922, when they were still playing at the Polo Grounds. The ever popular Babe Ruth is standing at the extreme right. (Author's collection.)

Edward and John McNamara were in Franz Sigel Park when this picture was taken in 1923. They are looking west toward East 161st Street and River Avenue, where ground had been broken and construction was underway on Yankee Stadium. The world-renowned ballpark opened on April 18, 1923. (Courtesy John McNamara.)

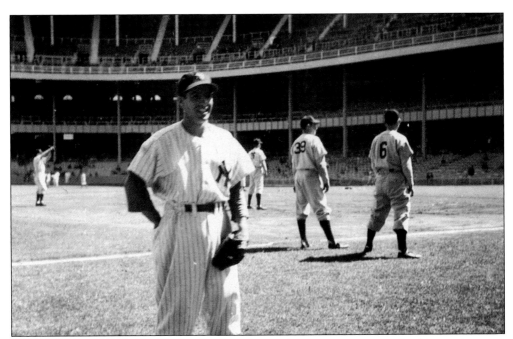

Phil Rizzuto is on the field at Yankee Stadium during the pregame warm-up for the opening game of 1946. This would be his first game since being mustered out of the service. Affectionately known as "the Scooter," Rizzuto retired in 1956 and became a Yankee radio and television announcer. His number, 10, was retired in 1985, and he was elected to the National Baseball Hall of Fame in 1994. Ernie Braca took this picture. (Courtesy John Robben.)

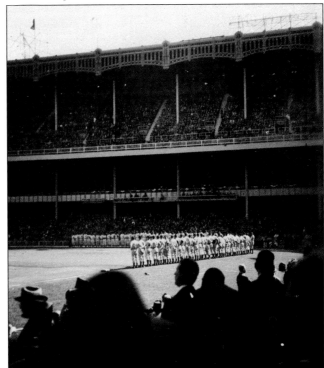

This photograph of the opening game of the 1946 season is interesting because it shows both teams on the field. The Yankees were playing the Washington Senators. Note the facade atop the third deck in the dim background. It was thought to be made of copper. However, when the stadium was renovated between 1974 and 1975, they found that it was made out of base metal. A replica now stands behind the bleachers. Ernie Braca took this photograph. (Courtesy John Robben.)

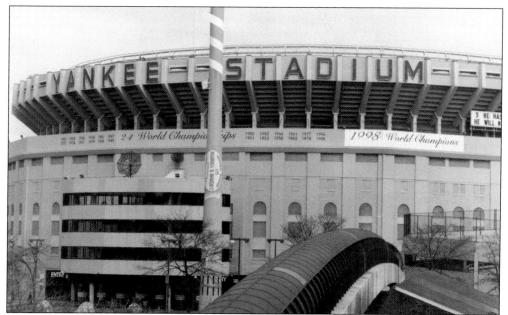

The White Construction Company built Yankee Stadium in only 284 days. Jacob Ruppert purchased the 11.6-acre site in 1921 for $560,000. The first game at the new stadium was held on April 18, 1923, against the Boston Red Sox, and Gov. Al Smith threw out the first ball. The Yankees won. This photograph shows the stadium after it was renovated.

This photograph gives us a grand view of Yankee Stadium as seen from Joyce Kilmer Park. It is interesting to note that this is the first ballpark to be called a stadium. The original cost of construction was only $2.4 million, but renovation costs in the 1970s reached $100 million. It is considered one of the most important structures in the borough and draws visitors from around the globe.

Seven

CEREMONIES, AWARDS, AND PARADES

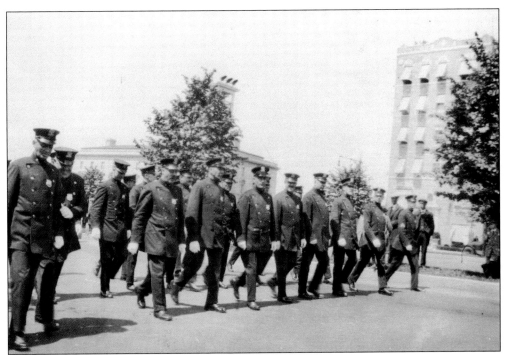

The New York City Police Department always provided a significant contingent in the Bronx Memorial Day parade. This photograph was taken on May 30, 1924, on the Grand Concourse. (Courtesy John McNamara.)

The armed services generally led the way in the Bronx Memorial Day parade. This one was held on May 30, 1924, on the Grand Concourse. Two young boys can be seen in front of the car between the marchers and are appropriately garbed in knickers and caps. (Courtesy John McNamara.)

The men in this 1924 Memorial Day parade on the Grand Concourse are carrying the banner of the Association of Bronx Old Timers. The organization was established on April 30, 1911, and was incorporated two years after this picture was taken. Membership required living in the Bronx for 50 years and being able to prove it. Time away for military service or any other reason was deducted. (Courtesy John McNamara.)

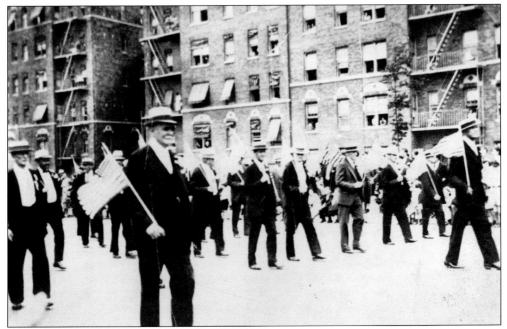

The Bronx Old Timers formed a good-sized contingent in this May 3, 1936 parade held on the Grand Concourse. Dr. John F. Condon is second from the left in the foreground with the flag. The man leading the contingent at the far right is Carl Geib. Condon was a longtime principal of Public School No. 12 and is also remembered as the intermediary in the Lindbergh kidnapping case. (Courtesy John McNamara.)

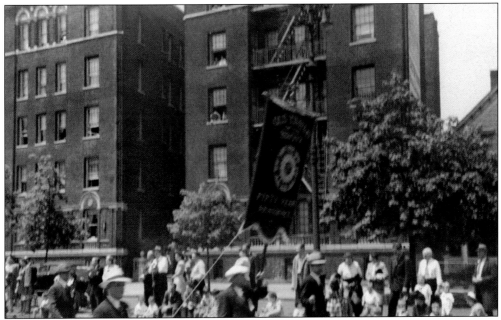

The Bronx Old Timers rarely missed a parade and proudly bear their banner in this Memorial Day parade held on May 30, 1946, on the Grand Concourse. The organization has since died off, and the last surviving member was historian John McNamara. (Courtesy John McNamara.)

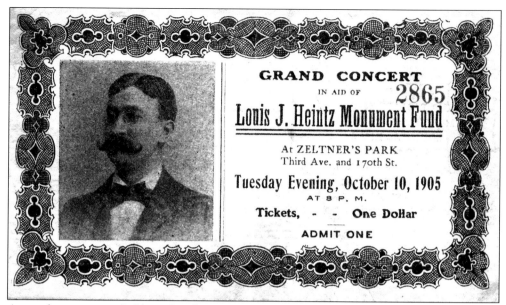

A grand concert was held on October 10, 1905, at Zeltner's Park (located at Third Avenue and East 170th Street) to raise money for a monument to honor Louis J. Heintz. He was one of the most popular municipal and civic leaders of the day and died rather young. This is ticket No. 2865, which required a $1 donation and entitled one to admission to the concert. (Courtesy John McNamara.)

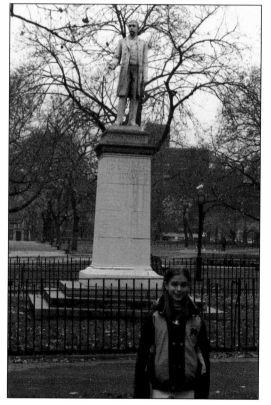

The memorial to Louis Heintz is located in Joyce Kilmer Park, at East 161st Street and Walton Avenue. The money for this fine memorial was raised privately through such affairs as noted above. The young girl in the foreground is Erin Twomey. (Photograph by Bill Twomey.)

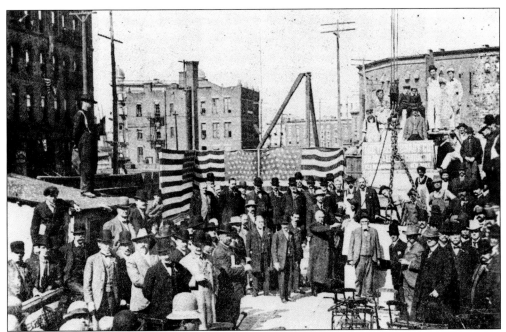

The cornerstone of the Bronx County Courthouse, at East 161st Street off Washington and Third Avenues, is being laid in this May 1911 photograph. Judges Louis Gibbs, George Schulz, and John Brady officially opened the building on January 6, 1914. (Courtesy John McNamara.)

Opening of
The George Washington Bridge
Saturday, the twenty-fourth of October, 1931
at two o'clock in the afternoon

Admit

(Guest)

to the Grandstand

Present this card at the Armory of the 102nd Engineers
168th Street and Fort Washington Avenue, New York
or at either end of the Bridge

Not transferable

No automobiles allowed on the Bridge

This official ticket was for the admittance of one person to the grandstand for the opening of the George Washington Bridge on Saturday, October 24, 1931, at 2:00 in the afternoon. (Courtesy John McNamara.)

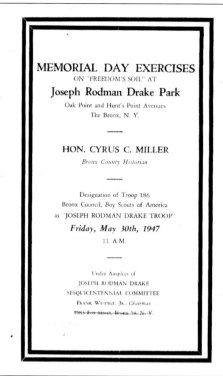

MEMORIAL DAY EXERCISES
ON "FREEDOM'S SOIL" AT
Joseph Rodman Drake Park
Oak Point and Hunt's Point Avenues
The Bronx, N. Y.

—

HON. CYRUS C. MILLER
Bronx County Historian

—

Designation of Troop 186
Bronx Council, Boy Scouts of America
as "JOSEPH RODMAN DRAKE TROOP"
Friday, May 30th, 1947
11 A.M.

—

Under Auspices of
JOSEPH RODMAN DRAKE
SESQUICENTENNIAL COMMITTEE
FRANK WUTTGE, JR., *Chairman*
1983 Fox Street, Bronx 59, N. Y.

Memorial Day exercises were held at Joseph Rodman Drake Park at Oak Point and Hunts Point Avenues on Friday, May 30, 1947. The ceremony was held under the auspices of the Joseph Rodman Drake Sesquicentennial Committee. Frank Wuttge Jr. served as chairman. The order of the day and comments by Wuttge are within, and the rear cover contains two poems—one by Dickson Wallace about Drake and the other by the famed poet for whom the park was named. (Courtesy John McNamara.)

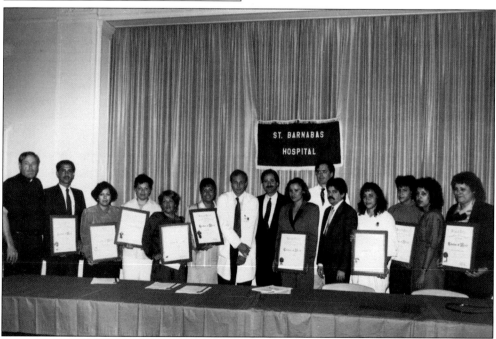

Puerto Rico was hit hard by several hurricanes in the late 1980s, and members of St. Barnabas Hospital Relief Team were there to help. Nydia Velasquez, the community affairs secretary for the government of Puerto Rico, joins borough president Fernando Ferrer in presenting citations of merit to Dr. Ronald Gade and his team. (Author's collection.)

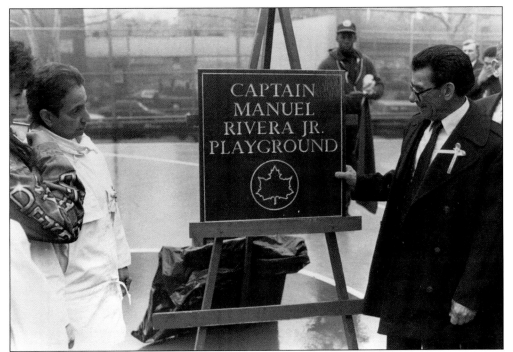

Capt. Manuel Rivera Jr. was honored on April 15, 1991, when the Forest Park Playground at St. Mary's Houses was named for him. The Marine fighter pilot lost his life on January 22, 1991, during the Persian Gulf War. (Author's collection.)

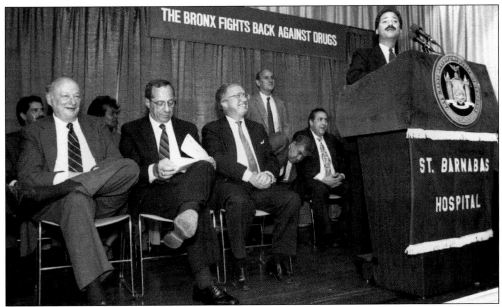

Borough president Fernando Ferrer speaks at St. Barnabas Hospital on the theme "the Bronx fights back against drugs." Mayor Ed Koch and Gov. Mario Cuomo await their turn to speak.

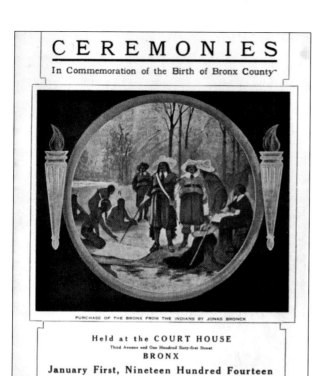

CEREMONIES

In Commemoration of the Birth of Bronx County

PURCHASE OF THE BRONX FROM THE INDIANS BY JONAS BRONCK

Held at the COURT HOUSE
Third Avenue and One Hundred Sixty-first Street
BRONX
January First, Nineteen Hundred Fourteen

Ceremonies were held at the Bronx County Courthouse (located at East 161st Street and Third Avenue) on January 1, 1914, to celebrate the birth of Bronx County. Borough president Joseph F. Periconi presented this souvenir program to the Bronx Rotary on January 7, 1964. (Courtesy John McNamara.)

The rotunda of the Bronx County Courthouse, at the Grand Concourse and East 161st Street, was rededicated as Veteran's Memorial Hall in a ceremony held on November 14, 1988. There was a flyover by the Air National Guard and a 19-gun salute, after which the Cardinal Spellman High School Band played some patriotic tunes.

The first Columbus Day parade in Belmont was held in October 1988. Joe Pressimone made this float bearing the *Nina*, *Pinta*, and *Santa Maria*. (Courtesy John McNamara.)

Borough president Fernando Ferrer (left) shows off the sign announcing the celebration of the 350th anniversary of the Bronx in 1989.

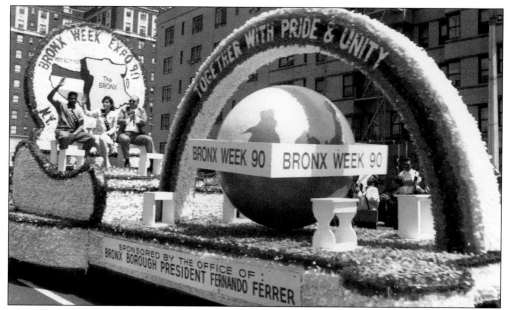

The office of borough president Fernando Ferrer sponsored this float celebrating Bronx Week 1990. The theme of the float is "together with pride and unity."

Political leaders gather to celebrate the genesis of the Hunts Point Cooperative Market on August 25, 1998. A check in the amount of $7 million was displayed with the words "The Assembly Majority Creating Real Jobs for New York."

Eight

PEOPLE AND PLACES

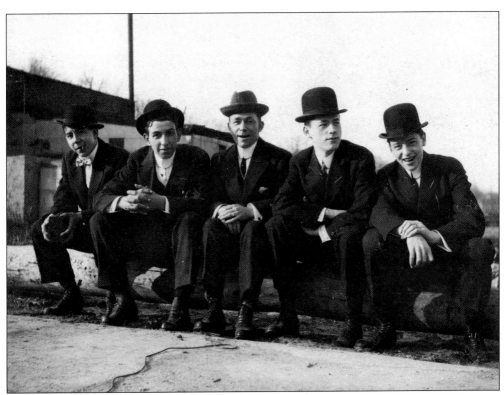

These young men, who belonged to a walking club, have stopped to rest on a log on the sidewalk of East 165th Street near Jerome Avenue. From left to right are Fred Becker, Carl Titus, George Beall, and Eric and Bill Dufour. The picture was taken on March 31, 1912. (Courtesy John McNamara.)

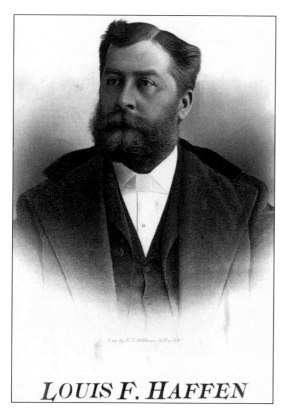

LOUIS F. HAFFEN

Louis F. Haffen was born in the Bronx on November 6, 1854, and attended the Village of Melrose School on East 150th Street between Melrose and Courtlandt Avenues. His high school years were spent at the Melrose Public School, on Third Avenue near East 157th Street, after which he attended St. John's College, now Fordham University. He also received a degree in engineering from Columbia University. He held a number of municipal posts before becoming the first president of the Bronx, a position he held from 1898 to 1909. This photograph was taken c. 1905. (Courtesy John McNamara.)

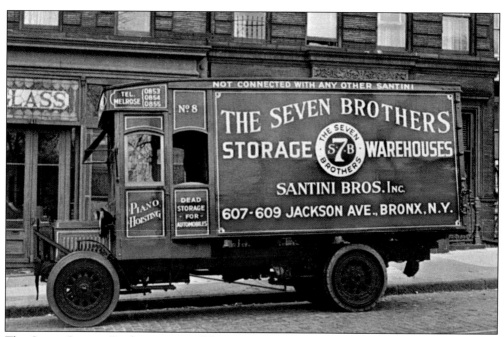

The Seven Santini Brothers were well-known movers, with headquarters at 607–609 Jackson Avenue. This early moving truck was a 1920 four-cylinder Packard. (Courtesy Thomas Casey.)

The Adams & Flanagan Company Department Store was located on the south side of Westchester Avenue between Third and Bergen Avenues for many years. This picture postcard was taken there during Christmas week of 1914, and the child is John McNamara. (Courtesy John McNamara.)

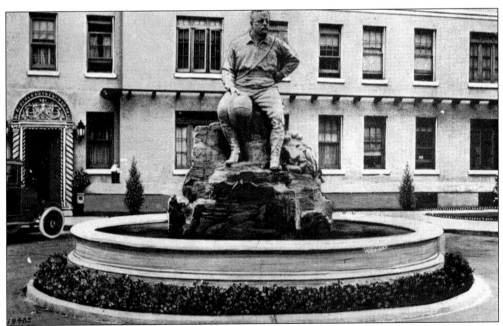

The Roosevelt Apartment Building, located at 1475 Grand Concourse at East 171st Street, was among the finest such complexes in the Bronx when it opened in 1924. The statue of Theodore Roosevelt, shown here, is long gone. (Courtesy Thomas Casey.)

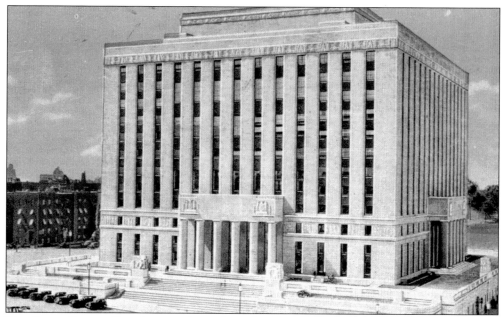

The Bronx County Courthouse is located on the Grand Concourse between East 158th and East 161st Streets. Construction began in 1931. It was completed in 1934 and dedicated in June of that year. (Courtesy Thomas Casey.)

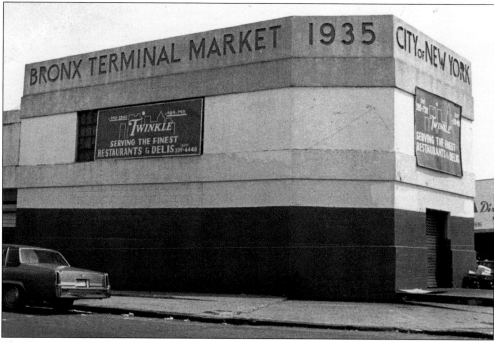

The Bronx Terminal Market is located just east of the Major Deegan Expressway and south of Yankee Stadium. It was opened in 1935 by Mayor Fiorello LaGuardia, who cut the ribbon at the grand opening ceremony. (Courtesy John McNamara.)

The Armstrong family held a house party in their apartment above their store, located at 2582 Third Avenue, in 1932. Among those who can be identified are Joseph Armstrong; his parents, Jacob and Florence Armstrong; his sister, Novella Armstrong; and Bill and Vera Rannow. (Courtesy Bill Armstrong.)

There is a touch of glamour in this 1959 photograph of Sarah Santangelo stepping out of her 1959 Pontiac. The scene could have been photographed in Hollywood, but the picture was taken on Courtlandt Avenue at the corner of East 153rd Street.

CONCOURSE PLAZA HOTEL - Grand Concourse at 161st Street, New York, N.Y.

The Concourse Plaza Hotel, located at the northeast corner of the Grand Concourse and East 161st Street, was built in 1922. Designed by architect Paul Revere Henkel, the 500-room hotel is a fine example of the Art Deco buildings for which the Grand Concourse is noted. It was reconditioned by the city in 1974, and 300 apartments were created for the elderly. (Courtesy Thomas Casey.)

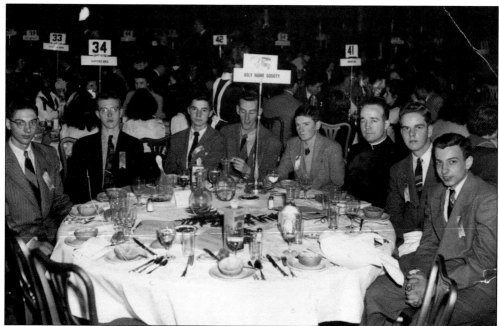

The grand ballroom of the Concourse Plaza Hotel could accommodate 2,000 guests. The diners shown in this 1946 photograph are members of the Cardinal Hayes High School debating society. The priest is Fr. John Grace. (Courtesy Jack Sauter.)

This photograph was taken at South Brother Island in August 1913, and the young boy at the right is Joseph Armstrong. This islet in the East River is now a bird sanctuary. (Courtesy Bill Armstrong.)

In this 1947 view, teenagers from Cardinal Hayes High School are celebrating another win by their football team. From left to right are Art Leone, Ed Menninger, Larry McBride, Jim Skinner, and Jack Sauter. (Courtesy Jack Sauter.)

The Benevolent and Protective Order of Elks, Lodge 871, was a longtime landmark at 2050 Grand Concourse at Burnside Avenue. For years, a large elk head adorned the building. This photograph shows some of the crowd that arrived for a grand bazaar held from November 16 through 23, 1946. Each evening of the bazaar, another car was raffled off. The advertisements read, "8 nights, 8 autos." This was an annual event that drew crowds from the entire metropolitan area. (Courtesy John Collazzi.)

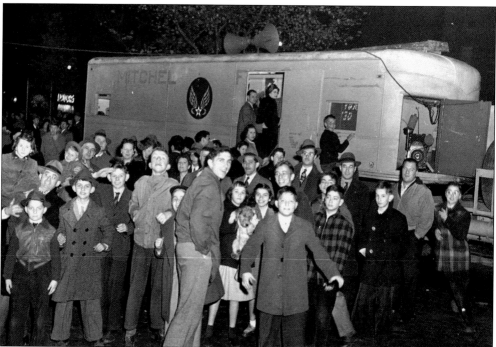

The Benevolent and Protective Order of Elks was founded in New York City in 1868, and members of Lodge 871 were among the most active. This picture of a floodlight display was taken in 1946. (Courtesy John Collazzi.)

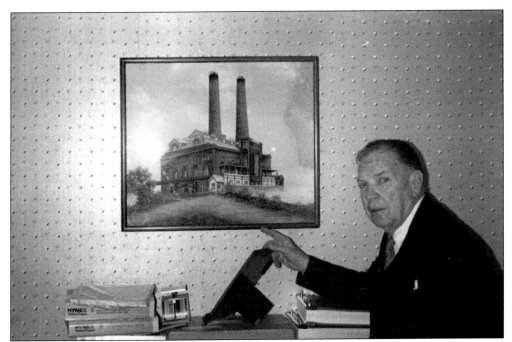

The subject of this painting is the New York Central's old powerhouse at East 149th Street and the East River in Port Morris. When Louis Collazzi painted this picture c. 1940, the building was leased to Con Edison. The author took this photograph of Bronx historian John McNamara examining the painting on March 3, 1990. (Photograph by Bill Twomey.)

The Ward Baking Company facility is located on the west side of Southern Boulevard north of East 142nd Street. The white brick building extended back to Wales Avenue, where the delivery trucks entered to be loaded. The baking ovens were located on the four floors above the loading docks. Clerical staff occupied the top floor. (Photograph by Bill Twomey.)

This picture was taken in 1947 at the playground located at Valentine Avenue and East 183rd Street. From left to right are Bob Lomas, Jack Hassett, Tommy Leavey, Monk Morris, Romey Brady, Richy Looney, Jack Sheehan, and Tony Amato. (Photograph by Ernie Braca.)

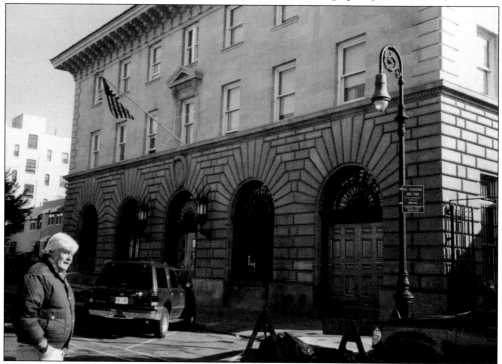

Police historian Mike Bosak stands in front of the 41st Precinct on Simpson Street. It originally opened at 1086 Simpson Street on June 8, 1914, as the 62nd Precinct. It relocated to 1035 Longwood Avenue on July 10, 1993. (Photograph by Bill Twomey.)

This fascinating photograph with the Fordham Road sign was taken at the 38th Parallel in Korea in 1952. Tony DiPalma is kneeling in front. The others are, from left to right, Michael Icavone, Seymour Dule, Al Sommantico, and Al Zagaria. All are from the area of East 187th Street and Crotona Avenue. Borough president James J. Lyons had the street sign sent to them as a reminder of home. (Courtesy Tony DiPalma.)

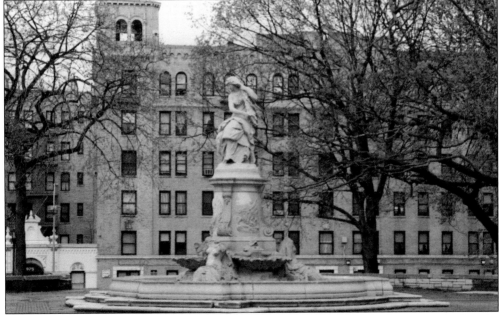

The author took this photograph of the Heinrich Heine Fountain (also known as the Lorelei Fountain), in Joyce Kilmer Park, before it was restored and moved farther south toward East 161st Street. This is a westerly view from the Grand Concourse near East 164th Street. Heine has long been considered among Germany's most important poets of the 19th century, second only to Goethe. The fountain was sculpted by Ernest Herter in 1888 and was erected in the park on February 1, 1899. (Photograph by Bill Twomey.)

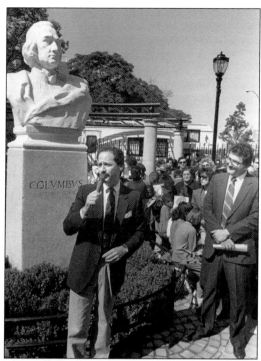

Borough president Fernando Ferrer speaks at the opening ceremony celebrating the 500th anniversary of Columbus's voyage. The picture was taken in D'Auria-Murphy Square in Belmont in October 1992. (Courtesy John McNamara.)

Charlotte Gardens is bounded at the north by East 174th Street, on the east by Southern Boulevard, on the south by Jennings Street, and on the west by Crotona Park. The South Bronx Development Organization received $3 million in federal aid and erected a complex of 94 ranch-style homes in the summer of 1983. This view is to the northwest up Charlotte Street from the northwest corner of East 170th Street. (Photograph by Bill Twomey.)

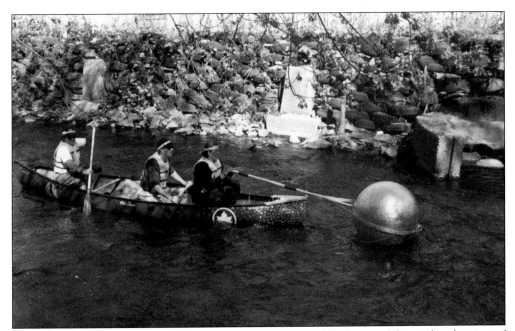

Con Edison joined with the New York City Department of Parks to celebrate the cleaning of the Bronx River. A golden ball was floated down the river, and community groups along the way joined in clean-up activities to show their respect and concern for the waterway. This picture was taken in 1999, and the practice continues today.

Engine 82, Ladder 21, of the New York City Fire Department is located on Intervale Avenue at the junction of Home and East 169th Streets. Once the busiest firehouse in the city, it was relatively quiet when this picture was taken on October 19, 1999. Mike Bosak is at the right. (Photograph by Bill Twomey.)

The Bronx Zoo was opened to visitors on November 8, 1899, at which time it showcased 843 animals. It now has more than 4,000 on its 265 acres. The Rainey Gate entrance off Fordham Road leads to Astor Court. This photograph was taken in August 1984. (Photograph by Bill Twomey.)

The Boathouse Restaurant was built on the shore of Bronx Lake in the southern area of the zoo near East 182nd Street and Boston Road. Diners could rent a rowboat after eating and enjoy rowing about on the lake. (Courtesy John McNamara.)

Bronx Park was somewhat less restrictive when Donald Braithwaite took this photograph on March 20, 1921. Many areas were still open to the public since they had far fewer exhibits. (Courtesy John McNamara.)

The Rocking Stone, located north of the Boston Road entrance, is a 30-ton granite boulder measuring 7½ by 10 feet. Despite its size, it can be easily rocked when pushed in just the right place. It was deposited here during the Ice Age. (Courtesy John McNamara.)

Adam and Eve, two Algerian donkeys, pulled this cart. It was a popular ride for youngsters, and a uniformed attendant was always present, as noted in this early Bronx Zoo postcard. (Courtesy John McNamara.)

Jack McCarrick is astride a pony at the children's zoo in Bronx Park in this 1957 photograph. (Courtesy Jack McCarrick.)

Architects George L. Heins and C. Grant LaFarge designed the Elephant House in the Bronx Zoo. Its design was based on the Palais des Hippopotames in Antwerp, Belgium, and it opened in 1909. It was completely restored in the 1990s. (Photograph by Bill Twomey.)

The Sea Lion pool is among the most popular exhibits at the Bronx Zoo, and some will recall when they could purchase a small fish for a moderate fee to feed the seals. The exhibit opened in 1907 but has been remodeled a number of times.

The giant caterpillar's mouth marks the entrance to the Butterfly Zone at Astor Court. The exhibit draws approximately 385,000 visitors each season. (Photograph by Bill Twomey.)

The Congo Gorilla Forest is among the latest Bronx Zoo attractions and encompasses six and a half acres. The 30 gorillas in the exhibit form the largest breeding population of lowland gorillas in the country. It is well worth a visit.